FEDERICO ZERI (Rome, 1921-1998), eminent art historian and critic, was vice-president of the National Council for Cultural and Environmental Treasures from 1993. Member of the Académie des Beaux-Arts in Paris, he was decorated with the Legion of Honor by the French government. Author of numerous artistic and literary publications; among the most well-known: *Pittura e controriforma*, the Catalogue of Italian Painters in the Metropolitan Museum of New York and the Walters Gallery of Baltimore, and the book *Confesso che ho sbagliato*.

Work edited by FEDERICO ZERI

Text
based on the interviews between
FEDERICO ZERI and MARCO DOLCETTA

This edition is published for North America in 1999 by NDE Publishing*

Chief Editor of 1999 English Language Edition
ELENA MAZOUR (*NDE Publishing**)

English Translation
ANTHONY JAMES CASLING

Realisation
CONFUSIONE S.R.L., ROME

Editing
ISABELLA POMPEI

Desktop Publishing
SIMONA FERRI, KATHARINA GASTERSTADT

ISBN 1-55321-007-7

Illustration references

Alinari archives: 36, 37r, 45/XI.

Alinari archives/Giraudon: 33.

Giraudon/Alinari archives: 1, 2-3, 6-7, 10t, 25b, 32, 35, 40b.

Luisa Ricciarini Agency: 4t, 8tr-br, 9tr, 26b, 28t, 43, 45/V.

RCS Libri Archives: 6, 9br, 10b, 12t-b, 14t, 19tl, 21bl, 23tl-bl-r, 24b, 26tl, 26-27, 28b, 37l, 42tl, 44/IV-V-VII-IX-X, 45/III-VI-VIII.

R.D.: 2t-b, 4b, 4-5, 8tl-bl, 9l, 10c, 11, 13t-b, 14bl-br, 15t-b, 16tl-tr-b, 17t-b, 18t-b, 19bl-r, 20, 21t-br, 22, 24t, 29t-b, 30t-b, 31, 34t-b, 35bl-br, 38tl-tr, 39, 40t, 41, 42tr-b,44/I-II-III-VI-VIII-XI-XII, 45/I-II-VII-IX-X-XII-XIII-XIV.

Printed and bound by Poligrafici Calderara S.p.A., Bologna, Italy

* a registred business style of NDE Canada Corp.
 18-30 Wertheim Court, Richmond Hill, Ontario
 L4B 1B9 Canada, tel. (905) 731-12 88

The captions of the paintings contained in this volume include, beyond just the title of the work, the dating and location. In the cases where this data is missing, we are dealing with works of uncertain dating, or whose current whereabouts are not known. The titles of the works of the artist to whom this volume is dedicated are in blue and those of other artists are in red.

KANDINSKY
THE FIRST ABSTRACT WATERCOLOUR

Kandinsky is considered to be the first painter in the abstract style. The explosive force in his use of colour achieves a synthesis of form which is both rational and coherent. The painter uses abstract representations in

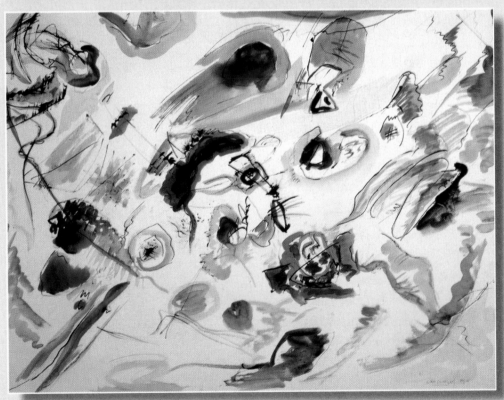

order to express his spiritual world. It is the highest and most lyrical artistic expression. All non-figurative artists are influenced by Kandinsky to whom we attribute THE FIRST ABSTRACT WATERCOLOUR.

THE MYSTERY OF THE DATE

THE FIRST ABSTRACT WATERCOLOUR
1911, ca.

● Paris, the National Museum of Modern Art, The Georges Pompidou Centre, donated by Nina Kandinsky (watercolour, ink and pencil on paper, 49.6cm x 64.8cm).
● The Russian painter and art theorist Vassily Kandinsky is the originator of abstract painting. A sophisticated artist among whose works "Improvisations" and "Compositions" is considered to be the first abstract painting. Kandinsky begins to experiment in the new style between 1908 and 1914. As a result of his contact in Munich with Jugendstil, a decorative style corresponding to *Art Nouveau* and *Liberty,* he becomes the leader of the avant-garde movements *Phalanx* and the *Blue Rider.*

● The *First Abstract Watercolour* becomes known throughout the world thanks to Nina, the artist's wife. It appears in the artist's personal catalogue as his first non-figurative work and is dated 1910. It is, stylistically very different to the works of that year however and much nearer to *Composition VII* of 1913., which is more probably when the work was accomplished.

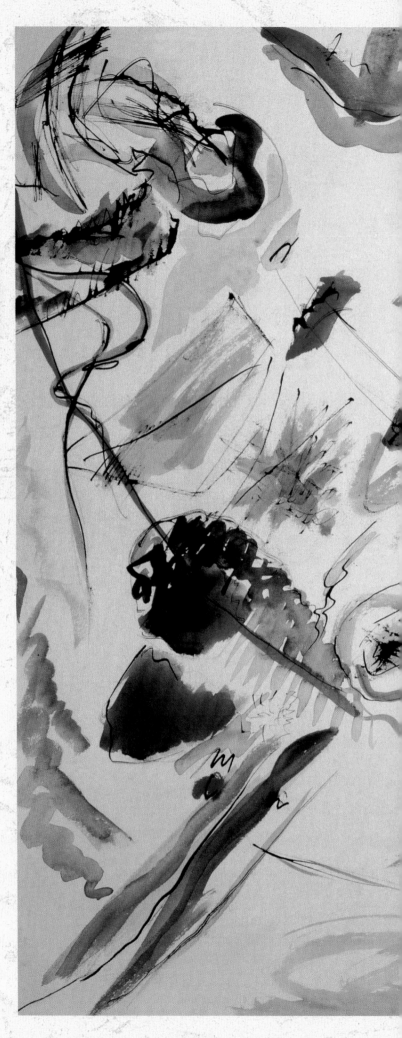

◆ VASSILY AND NINA KANDINSKY
The artist (Moscow 1866-Neuilly-sur-Seine 1944) with his second wife, Nina Andreevskaja. Above, *Composition VII* of 1913. (Moscow, Tre'tjakov Gallery).

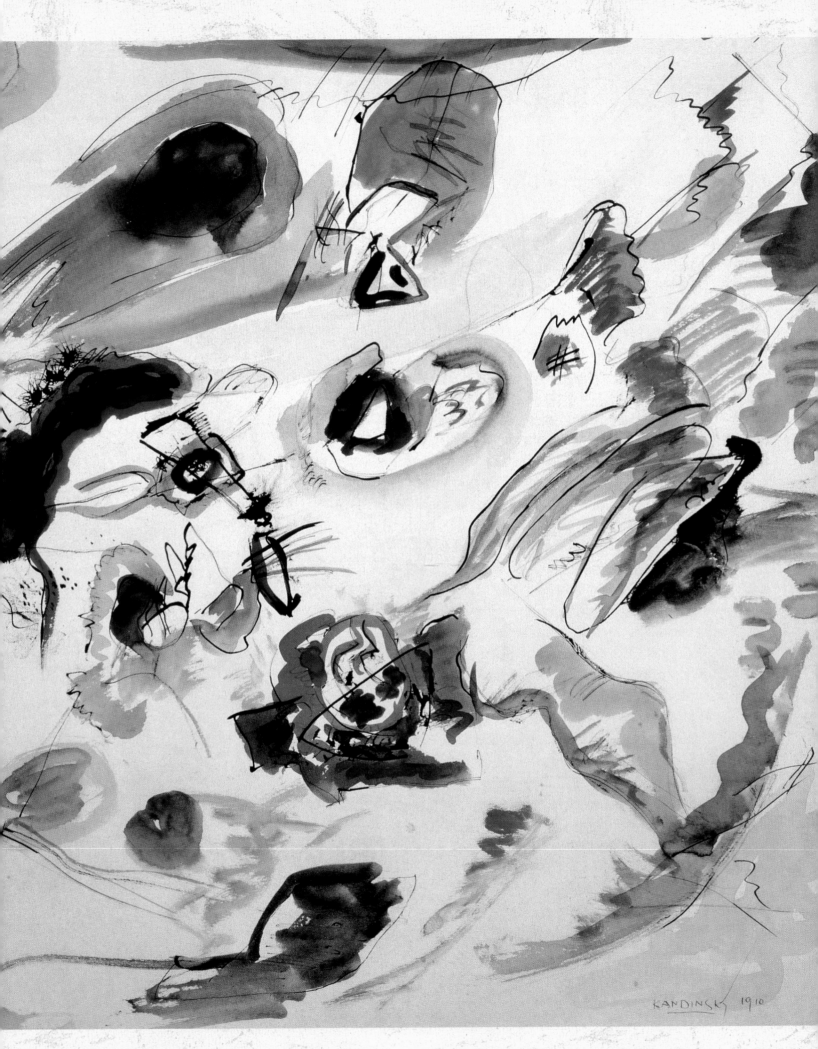

KANDINSKY 1910

3

EMBRACING THE FORM

The *First Abstract Watercolour* by Vassily Kandinsky is preserved in the Georges Pompidou Centre in Paris. Inaugurated in 1977, it is one of the most prestigious museums of modern art, a magnificent cultural "machine". This small watercolour is fundamental to the profound change in artistic expression in the early part of this century. As a consequence of Kandinsky's inner reflections and research the artistic expression of the real world is substituted with expressions of the artist's interior world. For Kandinsky, removing aspects of realism meant avoiding the impediments caused by the material world. It meant embracing the freedom of pure vision. His first abstract paintings are dispersed throughout the world. As a leading figure in the cultural life of Munich and with itinerant exhibitions around Europe the artist attempts to assert the principles of a new artistic conception. It has an uneasy reception by the public and critics, being criticised vehemently and stimulating heated discussion. For many years he was accused by his detractors of rigidity in his ideas and of being intellectually frozen. He was accused of having insufficient control over space and of having an egocentric conception of art, rendering communication impossible.

● He is not dismayed by the negative criticism however. It convinces him, in fact, to continue in his chosen direction, illuminated by the inner force of his aesthetic convictions. The bombs which rain on Schwabing, the artist's district where Kandinsky lives with his companion Gabriele Münter, are for the artist a sign that the whole world is deranged, and furthermore, is inseminated with the spirituality of art. In the eyes of his colleagues, painters who have been converted to abstractism by different means, his works reveal too much of their origins and show too many indications of natural elements. Even after painting his first abstract work Kandinsky continues to paint in a figurative manner until 1913.

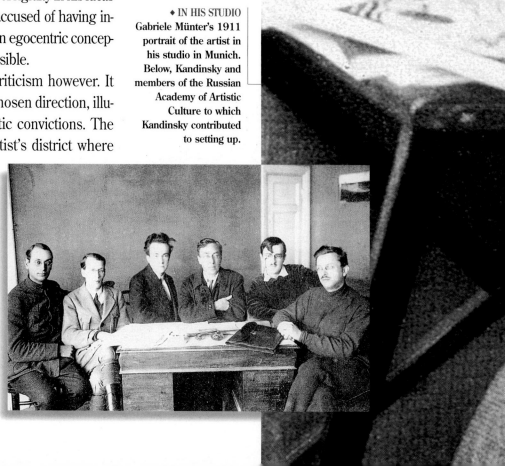

◆ RENZO PIANO AND RICHARD ROGERS
Georges Pompidou Centre
(Paris, 1971-77)
The Centre, constructed of glass and steel, is the home of the National Museum of Modern Art in Paris. It receives more than two million visitors every year.

◆ IN HIS STUDIO
Gabriele Münter's 1911 portrait of the artist in his studio in Munich. Below, Kandinsky and members of the Russian Academy of Artistic Culture to which Kandinsky contributed to setting up.

THE SPIRITUALITY OF A PURE IDEA

In 1910 Kandinsky is 44 years old. His past as a figurative artist is linked to the symbolist movement and the spiritual roots of Russian art. One afternoon, as told by the artist himself, returning to his studio he has a sudden revelation. A painting made up of new shapes and sparkling with original colours appears in his mind. It is the *First Abstract Watercolour.* Kandinsky has passed a period of profound reflection and inner struggle. His long aesthetic crisis results in the evolution of abstractism. It is the first great historical documentation of abstract painting. Western art is at a major turning point. After a long period of gestation the crisis of realism has emerged with a new distorted, expressionistic vision. An inner compulsion to assert an autonomy of expression is felt. There is a liberation from the material. It is the freeing of aesthetic meaning from the reproduction of nature. It is the birth of non-figurative art.

● The scintillating force, the elegance of the colours, the whirls of watery greens, blues, reds and blacks, joyously and dramatically exceed natural forms. The revolution even reaches the realms of space. Defying the laws of physics, opposing the laws of gravity, the greatest weights are found in the upper parts and the lightest fluctuate towards the bottom. The pictorial material is distributed in such a way that it does not have a structural centre. Kandinsky's compositions have a sense of balance. They are perfectly constructed.

● It is often said that the *First Abstract Watercolour* resonates with the figurative experience of the painter; in reality it cannot be denied that the pure idea is something spiritual, an expression of pure creativity.

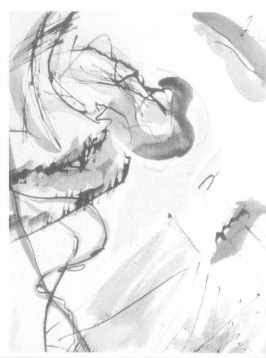

◆ THE EFFECTS OF AN IDEA
In 1910 Kandinsky, seen in his studio in the portrait on the left, holds an exhibition at the Salon D'Automne in Paris. Following this he visits St. Petersburg and Odessa where he makes contact with the principle exponents of the the Russian avant-garde, Natalja Gončarova and Michail Larionov.

◆ A GLANCE WITHIN
This joyous composition is achieved effortlessly as a first draft, without preparatory sketches. An initial idea plucked immediately it emerges from the depths of the soul is the effect which is felt. Mysticism and the inner search, characteristic elements of Russian culture, allow Kandinsky to be the first to create total abstractness in his paintings. On the right, the style of this period bring pictorial fragments to mind.

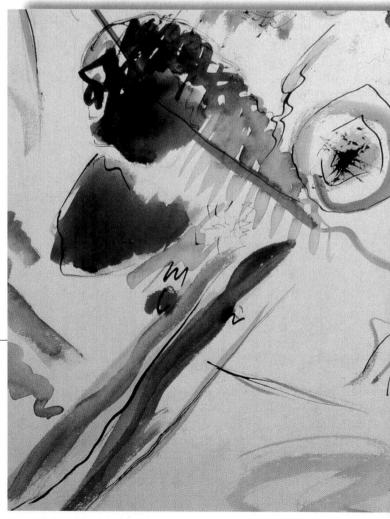

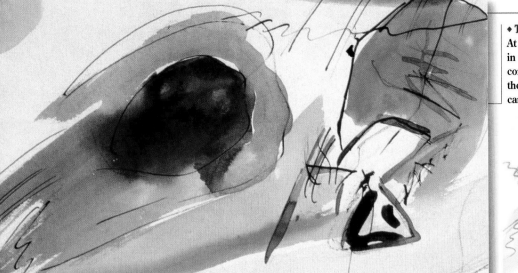

◆ THE COMET
At the top,
in the centre of the
composition a comet,
the colour of red-fire,
can be discerned.

This gives a strong
centripedal movement
to the whole work.
Kandinsky develops
in his compositions
as in musical
improvisation, without
having recourse to
descriptive motifs.
Critics have asserted
for many years
that the *First Abstract
Watercolour*
resounds with the
painter's figurative
experiences,
and leads one
to think of fragments
of a story or
a landscape.
The sensation that
the abstract figures
are straining to be seen
as real objects is felt.

**◆ AGAINST THE LAWS
OF GRAVITY**
The outlines of the
figure are vivacous and
agitated. The lines
move freely on the
surface without

having a constant
direction. They are
vibrant, breathing and
fluttering. They move
first from the bottom
to the top and then in
the opposite direction,

from top to bottom.
They defy the force
of gravity. The
new organisation of
space is one of the
principal innovations in
the work of Kandinsky.

THE WRITINGS

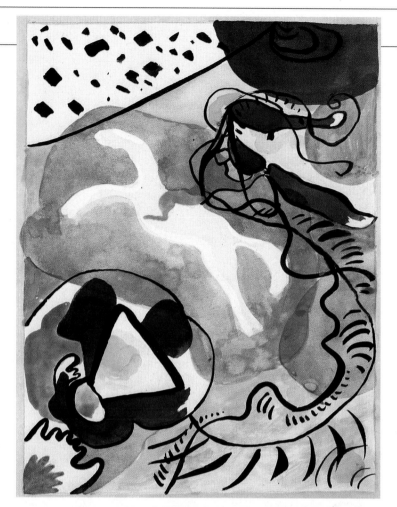

In 1911 Kandinsky publishes *On the Spiritual in Art* in Munich. This describes the principles of abstract art and Kandinsky's unsurpassed reflections on aesthetics. It becomes the principal reference point for all artists who are battling against the constraints of figurativism. The first words of the text become their battle cry, "Every work is a child of its time, and in many cases the mother of our sentiments". In its introduction Kandinsky declares:

● "Our spirits are at the point of awakening after years of materialism. The seeds of desperation are carried within them, caused by a lack of faith, a lack of purpose and a lack of an ideal. The nightmare of materialism, which has turned the life of the universe into a wicked, purposeless game, is not yet over. A small light flickers like a tiny point in an enormous black hole. This weak light is a glimmer of hope, which the soul hardly has the courage to see, believing that it is all a dream and the darkness is reality. (.....) After the materialist era, to whose evil temptations the spirit succumbed, there was a reawakening. The spirit, purged by trials and suffering is emerging. (....) It is quite rare that the observer of today feels such emotions. When viewing a painting he looks for mere imitations of nature which give sense to the work (for example a portrait in the usual sense), or a reproduction of nature with certain interpretative elements".

● When a new era of spiritual awakening arrives, a coerent theory of painting follows: "Just the form, as a representation of the object (whether or not it is a real object) or as a purely abstract definition of space, can exist by itself. It is not the same for colour. It is not possible to prolong colour without

◆ SKETCHES FOR THE BLUE RIDER ALMANAC (1911, Munich, Städtische Galerie im Lenbachhaus). Kandinsky draws a series of sketches for the cover of the *Blue Rider*. There is the figure of a horseman riding at full gallop in all of them. Above and below and on the following page there are three xylographs by Kandinsky. They are examples of the numerous studies for his compositions.

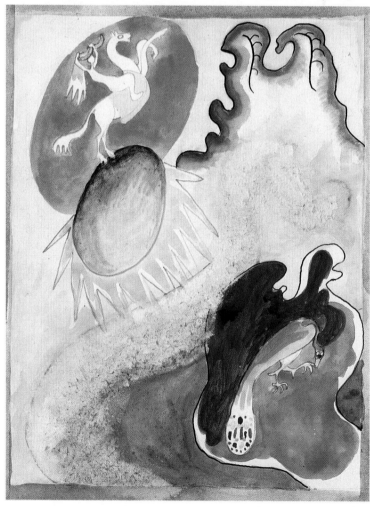

limits. Unlimited red is something that we can only imagine, or see spiritually. If we hear the word "red", the red which we have an image of does not have limits. Imposing limits, if this is necessary, must be done by constraint. On the other hand, the red which we do not see materially but which we feel abstractly, provokes an inner decription which is at the same time precise and imprecise. It has an interior physical resonance which is subjective and individual. This red is not specifically hot or cold. This is felt by the individual, as are subtle gradations in the tonality of the red.

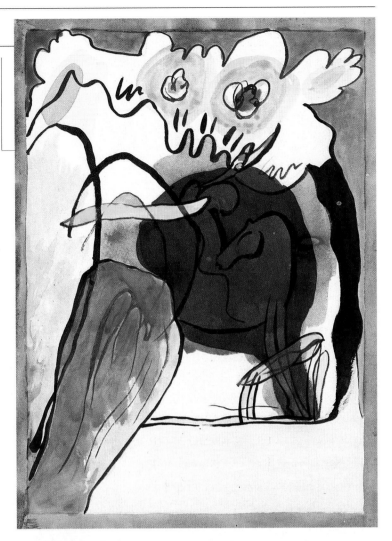

♦ SKETCHES FOR THE BLUE RIDER ALMANAC The choice of the name *Blauer Reiter* (Blue Rider) reveals Kandinsky's interest in animal symbolism. The figure of the horse is the embodiment of beauty, harmony and nobility. The Rusian master has always considered himself to be an aesthete.

● In 1912, a year after the publication of his revolutionary work on aesthetics, Kandinsky and his circle of artists in Munich publish *The Blue Rider Almanac*. This is received with critical contempt. The book is a large format publication with colour illustrations. It has contributions by Russian and German painters and musicians who work in the field of abstract art. The most significant contribution by Kandinsky is that concerning form.

● The artist observes lucidly in this respect, "At a particular moment, necesity matures. That is, the creative spirit (that which we can call the abstract spirit) manages to open a path to the soul, then in other souls. It incites a nostalgia, an interior impulse. When the conditions for the maturation of a certain form are realised, an inner force emerges which becomes strong enough to create a new value in the human spirit, a value which begins to live in the conscious and unconscious mind of man. When this happens, knowingly or unknowingly, man endevours to find a material form corresponding to the spiritual form which is alive in him".

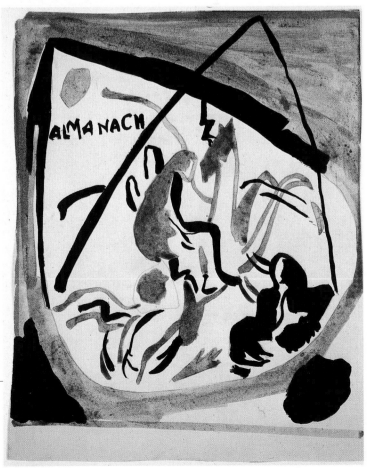

♦ SKETCHES FOR THE BLUE RIDER ALMANAC According to Greek mythology, of which Kandinsky has a profound knowledge, the first horse was given to man by the sea god: a strong, swift creature which comes from the water. Blue is used for the colour of the sky, the colour of transcendence.

DYNAMIC EQUILIBRIUM

An analysis of the composition of an abstract painting, in which the relationship between the formal elements appears at first sight to be quite free, can in fact be more complex. On close observation a precise structural relationship between the black and the the other colours and also between the shapes and the lines is discovered.

● The clearer tones are too weak to have autonomous movement and they act as connecting elements between the stronger colours: they are pure space between the masses of colour. A space which has a materialness, like the shapes. Kandinsky plays with spatial dynamism in the tones: warm tones are pushed forward and cold tones are pulled back. On every allusion to form, decisive lines are used to undermine them.

● On the left part of the composition, starting from the top corner, a decisive movement towards the centre can be discerned by the observer. It could be the figurative representation of the profile of a

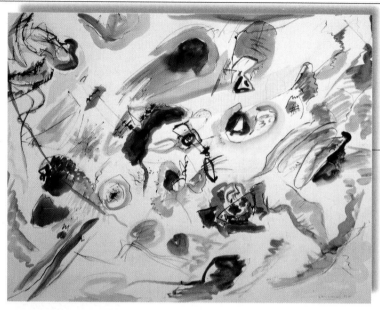

◆ VICTOR VASARELY
Composition
(1962, Galleria Notizie, Turin) Founder of Kinetic Art. The French painter, of Hungarian origin, studies the chromatic relationships between hot and cold colours in circles and squares.

◆ STUDY: COLOURS, SQUARES, AND CONCENTRIC RINGS
(1913, Munich, Städtische Gallerie im Lenbachhaus). When almost all figurative elements disappear from the composition and the practice of abstractism is a natural part of his artistic method, Kandinsky dedicates himself to a new research of colours, experimenting with colour combinations.

wide-open screaming mouth. In the right part the movement becomes distant and finally disappears beyond the limits of the composition.

● We face a plurality of forces, lines, masses and colours, all balanced dynamically. The universal rules of figurative art, imitative and static, are abandoned and with them the traditional means of interpreting a painting enter into a state of crisis.

● The dynamism and the rapidity of execution, and the lightness of forms and colours in *The First Abstract Watercolour* are expressed exquisitely with watercolour techniques. This is characterised by the use of distilled water as solvent for the colours, which are made from minerals or vegetables treated with glycerine and a transparent glue. Card which has been treated with ammoniac and ox bile, is used as a support. Kandinsky uses watercolours widely, exploiting their immediateness. He prepares the paints personally, mixing the various tones to suit his personal taste. The variety of colours which he mixes on his palette is extremely refined and poses great difficulties for fakers. The colours differ greatly between paintings and within the same painting.

◆ THE ROAD IS OPEN
With *The First Abstract Watercolour* Kandinsky inaugurates the era of abstractism, a movement which becomes diffused around Europe. It is developed at a theoretical level by the art historians Riegl and Wölfflin, and by the philosopher Worringer, who in 1908 publishes *Abstraction and Empathy*.

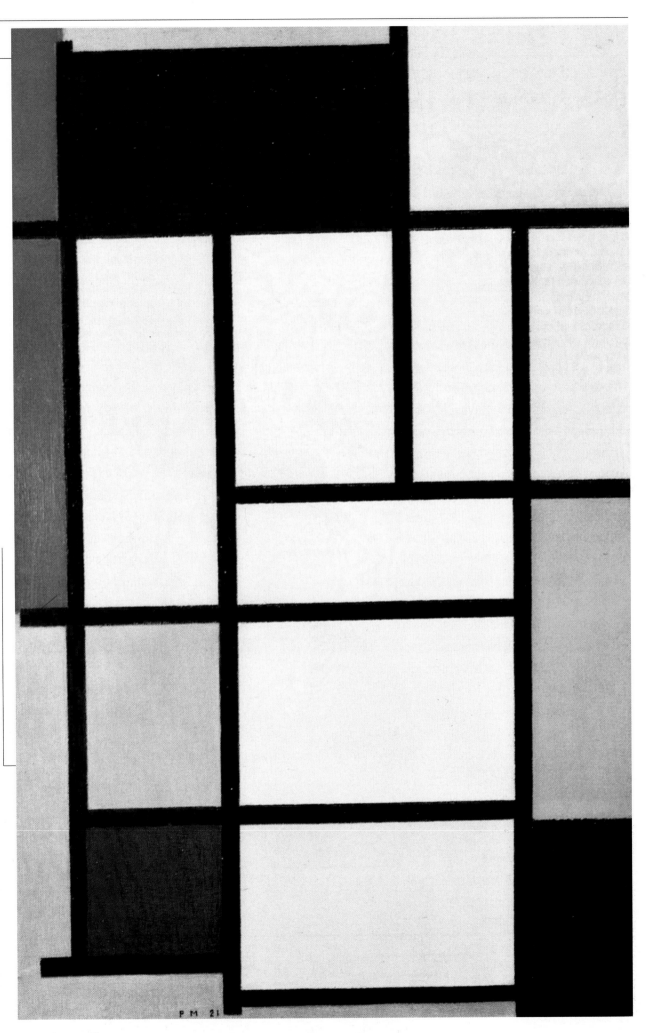

◆ PIET MONDRIAN
Composition with Red, Yellow and Blue
(1921, L'Aja Gemeentemuseum).
Having experimented with Cubism the Dutch painter and art theorist Mondrian distances himself definitively from the conventions of figurativism. Mondrian's abstraction, in contrast to the work of Kandinsky, is a purely conceptual abstraction. It consists of the systematic replacement of formal elements with vertical and horizontal lines which cross perpendicularly, closing in homogenous fields of primary colours. In 1917 Mondrian founded Neo-plasticism which is based on and develops the principles of abstractism.

THE FATHER OF ABSTRACTISM

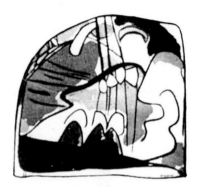

Kandinsky is the father of abstractism. He is one of the artists who have revolutionised modern art. He was born in Moscow in 1866. His mother is remembered for her great intelligence and beauty and his father for his wide culture and great openness. Unlike most artists, Kandinsky is unable to dedicate himself to his creative activities until he is thirty. He is certain about his destiny as a cultural reformer however and he becomes an explorer of an undiscovered, non-objective world. In 1896 he moves to Munich, a great cultural centre, a melting-pot and a centre for artists. For intellectual originality it is more advanced than Paris. In Munich Kandinsky is stimulated by various aspects of Art Nouveau. The direction which he takes is greatly innovative, theorising and accomplishing an art which is profoundly synthetic and non-descriptive. He founds *Der Blaue Reiter (Blue Rider)* an avant-garde movements which brings together Russian and German painters, musicians and writers. After seperating from his first wife, his second cousin Anna Federovna Semjakina, he publicly announces his love for the painter Gabriele Münter, a fellow researcher and member of the *Blue Rider* group.

● On the threshold of the first world war he leaves Germany and returns to Russia. He is extremely tenacious and of great humanity and he suffers greatly in the long exhausting war. He is tortured and tried by the loss of faithful companions and friends. He takes refuge in his place of origin and he continues his artistic research. He works intensely in this period. He does not hide the

dramatic inner tensions he feels from his conflict with Russian culture, not only in work but also in his personal life. In 1916 he leaves Gabriele Münter and marries Nina Andreevskaja.

● In 1921 Kandinsky has itinerant exhibitions throughout Europe. He is already famous but is compelled to leave Russia penniless and undernourished having lost all that he possessed. He is invited to Germany to teach at the Bauhaus School, the great institute of art and design which is at the forefront of artistic innovation and thought. He remains at the Bauhaus until its closure imposed by the Gestapo.

● He spends his final years in Paris. He is totally immersed in his painting. He renounces invitations and meetings in order to dedicate himself to his work, managing to tear himself away only when they are finished down to the finest details. In the meantime his praises are sung around the world. His fame has reached the USA where numerous exhibitions dedicated to him are held every year. He paints until when, on the 13 of December 1944, he dies suddenly from a stroke caused by arteriorsclerosis.

◆ FOR AND AGAINST (1929, New York, Thomas Gallery). It is the first Kandinsky painting acquired by Thomas Guggenheimer. Painted during his years at the Bauhaus, it is an oil painting on cardboard. The forms and colours, by this time, obeying their own laws.

◆ SKETCH FOR A WALL PAINTING (1922, Paris, The National Museum of Modern Art). During his years at the Bauhaus Kandinsky devoted himself to wall painting.

◆ VASSILY KANDINSKY A photograph of Kandinsky during a moment of reflection on the theory and principles of art. In 1911 his most important works *On the Spiritual in Art* and in 1926 *Point and Line to Plane* are published in Munich. At the top right of the page is a poster for an exhibition of the painter's work at the Maeght Gallery, Paris.

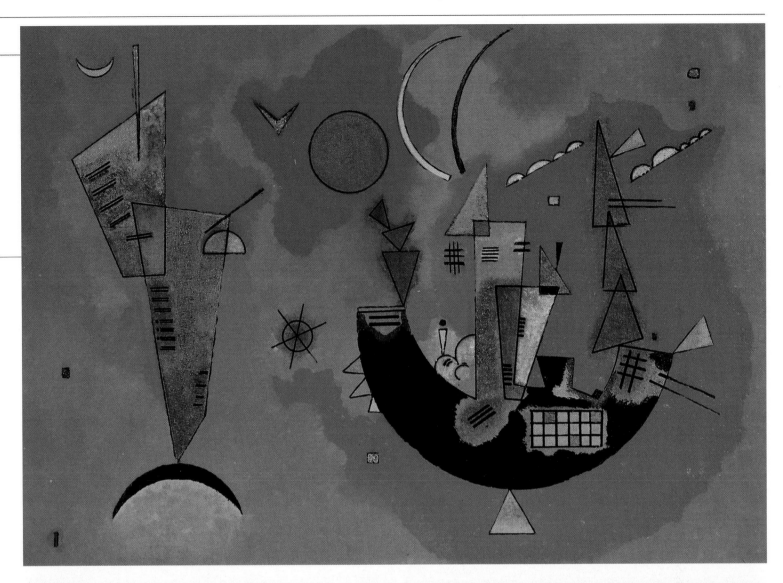

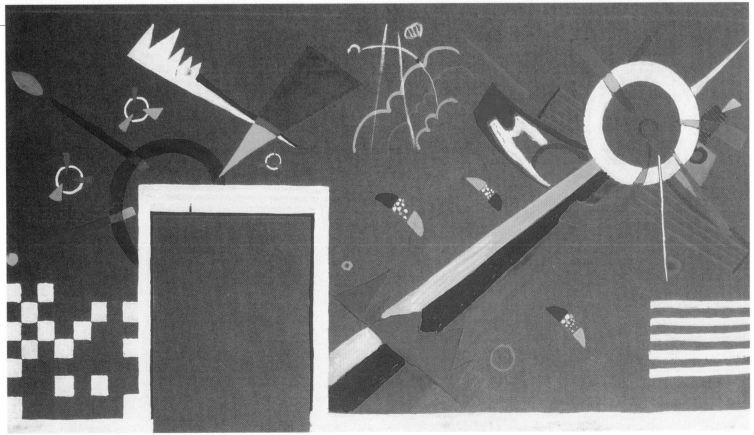

THE YEARS OF RESEARCH

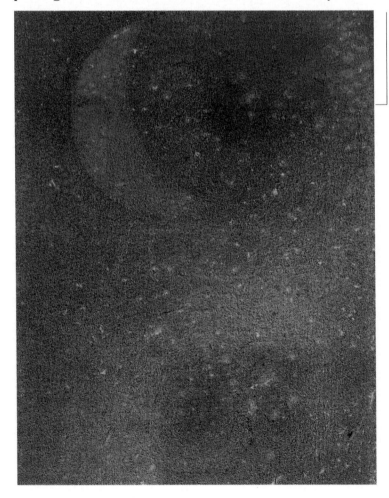

Kandinsky adopted numerous pictorial techniques in his vast production reflecting many years of continuous artistic research. In his first landscape paintings he spreads paint with a spatula in order to create wide fields of colour, making short, dense, irregular lines in the layer of applied paint. He invariably makes his own colours, not buying ready-made tubes. He mixes the powders and pigments with various glutinous substances, always in different ways.

● In the first years of the century his pictorial themes were taken from fairytales. He uses the technique of gouache, dissolving the colours in water and binding them with a transparent glue. The gradation of the colours is related to the quantity of white lead mixed with the liquid beforehand. When dry, the colours become clearer and assume a pastel-like effect.

● In the years spent in Murnau (1908-10) the tonalities in his paintings are more luminous and more vivid. Kandinsky moves away from the spatula technique and favours rapid, shaving, curved brush strokes. The effect is that the many layers which have been shaved from the surface of the cardboard form a dense paste on the surface of the painting. Besides his work on cardboard he also dedicates himself to painting on glass. This calls form a cohesion and synthesis of the forms. In painting glass the technique used is to paint on the back surface, the top surface remaining untouched. For this reason there is an inversion of many of the techniques used.

● At the *Bauhaus* Kandinsky uses the unusual technique of spraying watercolours, this produces effects of exceptional beauty. The colours appear to melt into each other with a smoke-like fluency. The master works with circles in this period, using delicate ink shading and subtle outlines,the circles appear to to fluctuate like bubbles of soap.

◆ BLUE VAPOUR (1928, private collection). The painting was in Nina Kandinsky's possession for many years. She had a great love for this work. The painting is from the period spent at the school of applied art, the Bauhaus in Dessau. The vaporous colours dissolve into each other giving a pastel effect. The technique of sprayed watercolours is used.

◆ TOO GREEN (1928, private collection) Kandinsky achieves this composition with the technique of sprayed watercolours, as used by his fellow-artist Paul Klee. The artist experiments with new optical principles. The work was given to Klee on his fiftieth birthday.

♦ BLUE MOUNTAIN (1908-09, New York, Guggenheim Museum). In the period, preceding his stay in Murnau, Kandinsky is involved in theoretical research and investigations into colour. He uses fast strokes and very compact lines similar to those of the pointillist movement of the post-impressionist era.

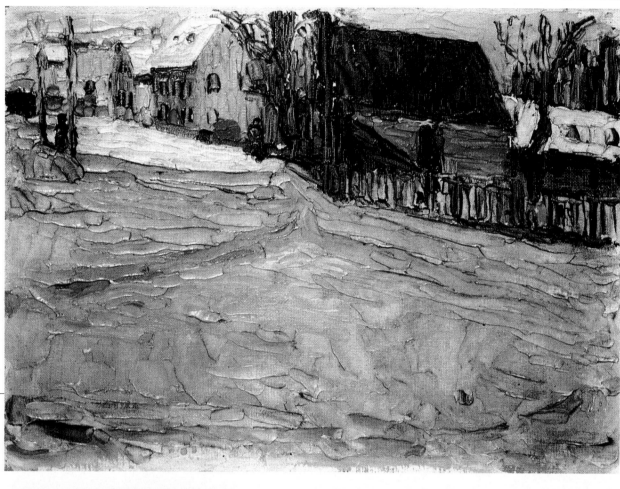

♦ URBAN LANDSCAPE (1902-03, Odessa, The Museum of Modern Art). This oil on canvas is from Kandinsky's figurative period. The artist uses a spatula in place of a brush to create unpretentious landscapes which appear to remain at the quick sketch stage. The spatula follows the lines of the object being depicted, oblique for the roofs and horizontal in the case of fields.

♦ WINTER LANDSCAPE 1 (1909, Saint Petersburg, Ermitage). This work, from his Murnau period, has an experimental character. Kandinsky assumes a new attitude towards nature. At this stage his new style is no longer demanding and feels superficial. He often paints with his left hand. He moves away from the spatula technique but still prefers the spontaneity of sketching.

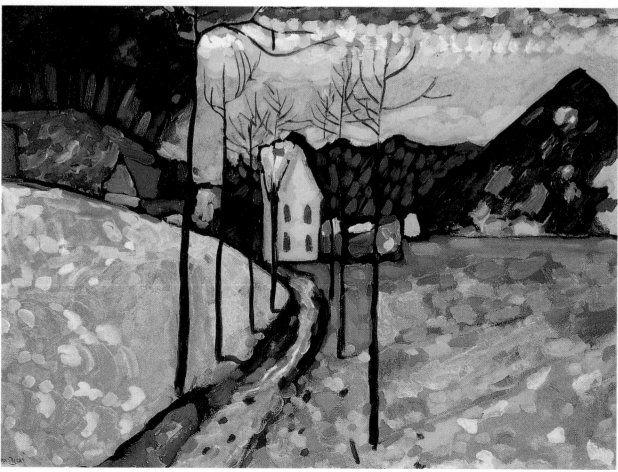

PAINTER AS A VOCATION

◆ MALE NUDE
(1897-98, Munich, Städtische Galerie im Lenbachhaus).
This study was carried out by Kandinsky at the school of Franz von Stuck. A section of a triptych of von Stuck, *Air, Water and Fire* of 1913 is shown below.

After graduating in law and political economy in Moscow he turns down the offer of a teaching post in Dorpat (presently Tallinn in Estonia). He moves to Munich in 1896 in order to follow a course in drawing and painting taught by Anton Azbe, a Slovenian painter with a great talent for teaching. He encourages his students to follow their own direction and to express themselves freely. Kandinsky attends the course, if infrequently. He is not completely convinced that he can receive the instruction he wants from Azbe's course. His teacher, in contrast to Kandinsky's attraction to all that is new, is still tied to a classical approach to the study of art. Detailed and realistic anatomical drawing are a component of thecourse. More interested in an organic, structural approach and the unity of forms, Kandinsky abandons Azbe. This first stage of Kandinsky's artistic education leaves no traces in his later work.

●However, in 1900, realising the weakness in his drawing skills he joins, not without great effort, Franz von Stuck's class at the academy in Munich. Von Stuck was considered at the time to have the finest drawing skills in Germany. Von Stuck was famous in Munich at the beginning of the century and was an instigator of the modernist movement. He helped thirty three year old Kandinsky to define his graphic style. Von Stuck vehemently opposed Kandinsky's use of colour, judging it extravagent and excessive, he suggested tonal painting.

◆ THE PORT OF ODESSA
(1896-98 circa, Moscow, the Tre'tjakov Gallery)
Kandinsky demonstrates a refined sense of colour in his first oil painting. The light diffuses in a uniform manner, as in the Nordic tradition. The shade is lost in dark, intense tones which bring to mind the style of Rembrandt. At the top right, the successive phase in his development in the study *Munich*. (1903, Odessa, The Museum of Art).

◆ CLAUDE MONET
Haystack
(1891, Zurich, Kunsthaus).
One of Monet's "Haystacks", the first modern painting to influence Kandinsky in the year before he left Moscow.

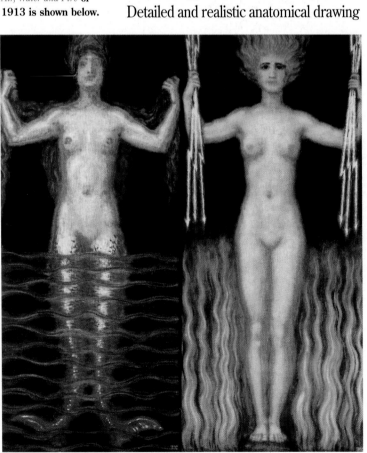

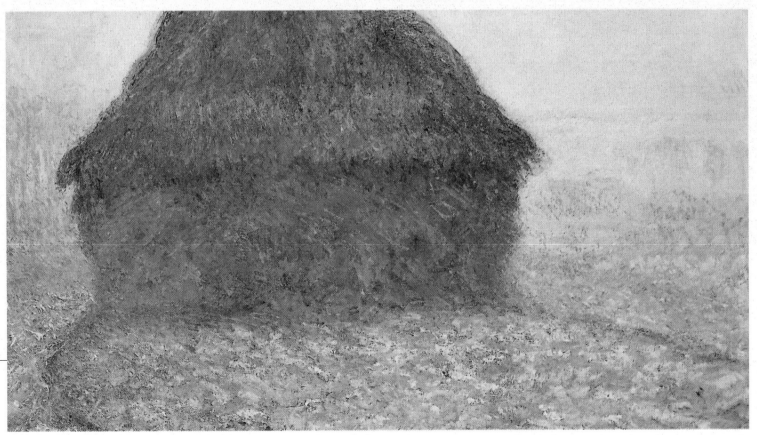

THE PHALANX GROUP

Kandinsky's period in Munich was one of intense, fertile artistic activity. Looking within himself for the road towards the spiritualisation of art he experiments with new forms and pulsating colours. Influenced by the *Jugendstil* and his love for symbolism, he forms the *Phalanx* group in 1901. The group, which is also a school, offers foreign artists the possibility to show their works in both individual and collective exhibitions. The theoretical work of the group does not consist of just merely criticising the traditional views of the accademy, new and concrete changes in the conditions for the production of art are proposed. The starting point is the admission of women into art studios and art schools from where they have previously been excluded. With the *Phalanx* group Kandinsky intended to close the distance between cultivated and popular art and between artists and craftsmen. Wiliam Morris had already outlined theories of this kind in England in 1888 in the *Arts and Crafts* movement,

◆ **VASSILY KANDINSKY**
At the age of thirty Kandinsky leaves Russia and movesto Munich. It is a city of great artistic ferment at the time. He seperates from his first wife in this period, his second cousin Anna Federovna Semjakina, and meets Gabriele Münter who will be his companion for the next ten years.

◆ **AUGUST ENDELL**
The facade of Elvira House
**(1896-97, Munich).
The stucco of the facade may appear to be in the *Art Nouveau* style, but was in fact an audaciously creative abstract decoration. It was covered with a layer of limestone during the Nazi period; it was destroyed during the bombing of 1944.**

stating that art is the joyous fruit of man's labour.

● After a long period in the artist's development and with the conclusion of the intellectual and aesthetic adventure of the *Phalanx* group in 1904, Kandinsky devotes himself full-time to the study of landscapes. This is a study which he initiated in the last decade of the nineteenth century. In small oil paintings on canvas he spreads resplendent, glazing colours, to capture the force of nature. The theoretical problems relating to the reflections of light and air are of no interest to him. Subjects are chosen on account of the fact that can be reached immediately: natural subjects.

● Kandinsky's personality, rich in tensions, characteristic of his Russian nature and of the culture in which he has been immersed since childhood, finds inspiration travelling and from subsequent visits to Moscow and Odessa. He paints a series of romantic pictures with themes taken from fairytales. They are highly decorative and assure him an initial success, are abruptly abandoned in 1907 however.

MUNICH

The Munich of Kandinsky in the years of the *Phalanx* group is still the "fabulous city of art". It had given rise to the Secession movement, ahead of Berlin and Vienna. Through vigorous discussion it reacted strongly to the anachronism and the aesthetical rhetoric of the accademy and prepared the city for an acceptance of international art. When Kandinsky arrived in Munich in 1896 he witnessed the birth of *Semplicissimus* a satirical paper produced by a left wing group. At this time the reforms of the *Jugendstil* movement were becoming more widespread, and embrionic elements which would be developed in the first forms of abstractism were in evidence. The scandal of August Endell's project for Elvira house, a photographic studio, shook the world of modern art. Art requires forms which are not weighed down by meaning and which do not have a relationship with real objects, which are capable of moving the spirit like only music can.

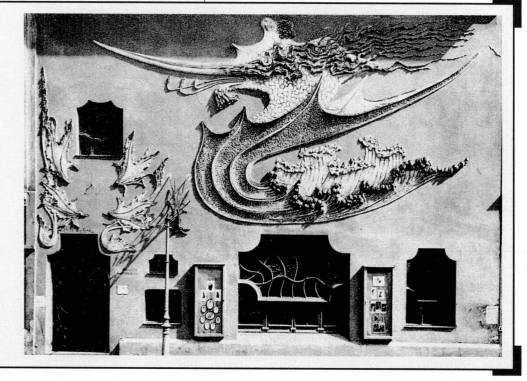

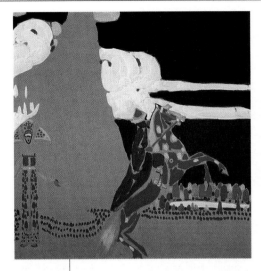

♦ THE HORSEMAN AND
THE PRINCESS
(1902)
The motif of the
horseman, which is very
dear to Kandinsky, often
returns in his work.
This elegant image
is replete with exotic
elements. It displays
the rich decorative style
of Russian icons
and oriental mosaics.

♦ POSTER
FOR THE COMPANY
ABRIKOSOV
(1896-97,
Munich, Stadtische
Galerie im
Lenbachhaus)
Like the *Phalanx*
poster, this is
an example of
Kandinsky's influence
by the Jugendstil.
It is not very well-
known. Printed in
Munich, of large
format, it was madefor
the chocolate factory
of relatives in Moscow.

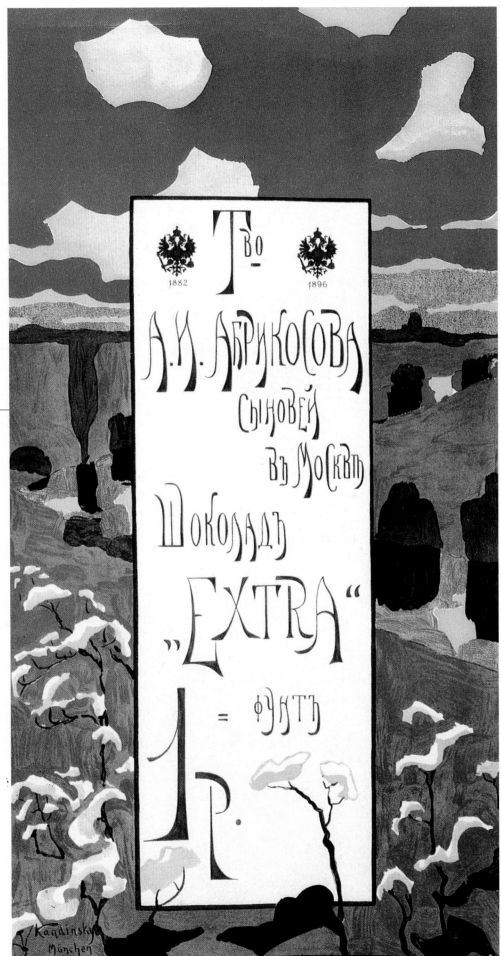

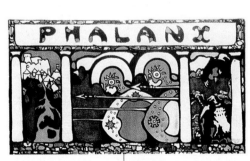

♦ THE *PHALANX* POSTER
(1901, Munich,
Städtische Galerie im
Lenbachhaus,
a detail).
Kandinsky produces
this colour lithograph
for the first *Phalanx*
exhibition.
The creation
of the group dates
from a protest against
the jury of the
accademy of art.
The jury favouring

a non-figurative
painting instigated
the formation
of the *Phalanx* group.
The group organises
exhibitions of the work
of Monet, Toulouse-
Lautrec, Signac and
Vallotton. It is the
paintings of Monet
which seminate doubts
in Kandinsky as to the
necessity of faithful
representation of
objects in paintings.

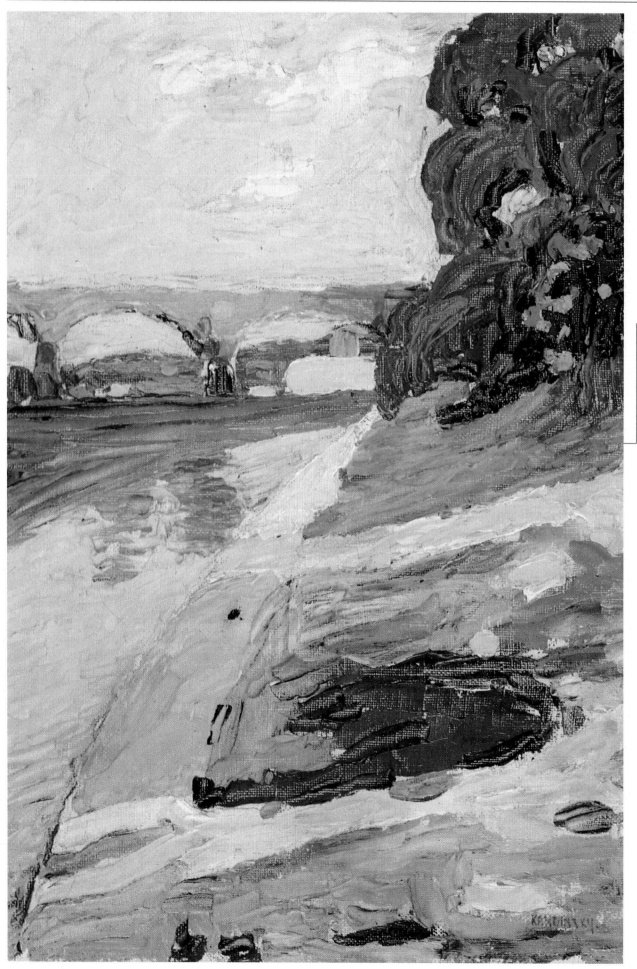

◆ SUNNY STREET
(1902-03, Odessa,
The Museum of Art).
Kandinsky prefered
landscape themes until
beginning at the
Academy. Almost ten
years seperates this
naturalistic subject
from the first abstract
works, which have an
autonomous expressive
force. Kandinsky
follows the example of
post-impressionist
paintings and
experiments with two-
dimensional
description in his
paintings.

◆ MUNICH WITH BRIDGE
(1901, Munich,
Städtische Galerie im
Lenbachhaus).
The reflection of the
bridge in the water
provides the stimulus
for the artist's
reflections on nature,
on the landscape.
This oil painting on
canvas is similar to his
first Russian paintings:
the sketch technique
which is used
demonstrates its
experimental character.

◆ IN THE WOOD
(1913, Turin,
The Civic Art Gallery).
In this painting
Kandinsky returns
to the use of
expressionistic tints.

◆ PAUL SERUSIER
*A Walk in the Forest
of Love (The Talisman)*
(1888, Paris,
private collection).
At the extreme
right. This painting
gave rise to the Nabis
School (which means
Prophet in Hebrew).
Dull colours
are prefered, with
no light and shade
effects. It influences
Kandinsky's work
with guaches.

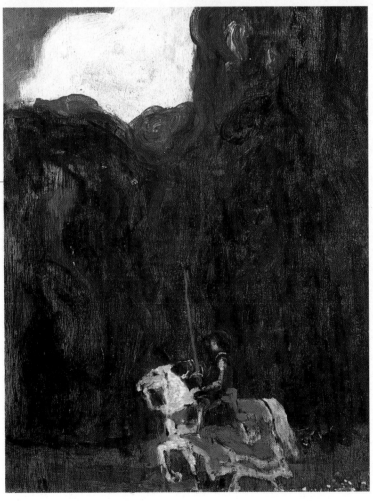

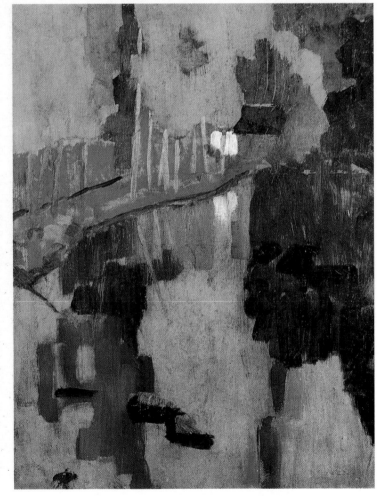

REFUGE IN BAVARIA

In 1909 Kandinsky and his companion, the painter Gabriele Münter, stay in a small Bavarian village, Murnau. It becomes the painter's favourite artistic laboratory in this period. The time spent in Murnau represents the first vital step towards abstractism. The inquiries and investigations carried out result in the change from the pure representation of objects. All the forms become simplified, to the point of consisting only of their colour. The colour is spread expansively and the contours are less well defined. He is fascinated with the dry, windswept alpine environment which purifies the tones of the colours. Without having fixed reference points, the artist draws all the angles of the village, creating a pictorial cycle, it becomes a "village of the spirit". The houses, the stations, the roads, and the countryside around Lake Staffel are studies in nature, an inner vision of nature however. Kandinsky acquires a house to which he invites his fellow painters. It becomes famously known as the *Russenhaus,* the Russian House.

● Kandinsky's work in this period has an experimental character. It is fresh, homogeneous and is the expression of a new attitude towards nature. Compared with his paintings of previous years, these are larger, bolder, with greater inner tensions. The elements within them feel more essential and "abstract". Kandinsky goes beyond the pictorial techniques of the Fauves, who at the Salon d'Automne in Paris in 1905, liberated the expression of colour, stretching them into pure tones. Kandinsky melts the shapes in brilliant fields of colour, endowing an even greater autonomy to the colours. His artistic output in this period is vast and in order to escape the routine of painting he often paints with his left hand.

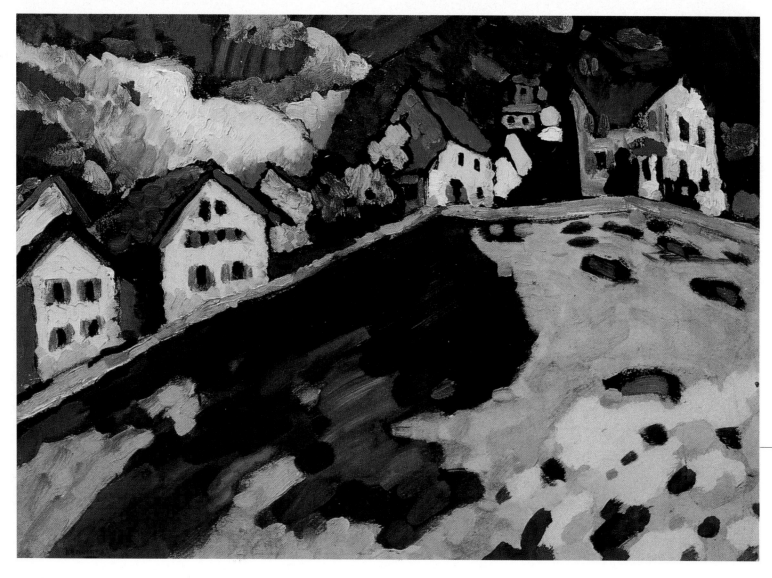

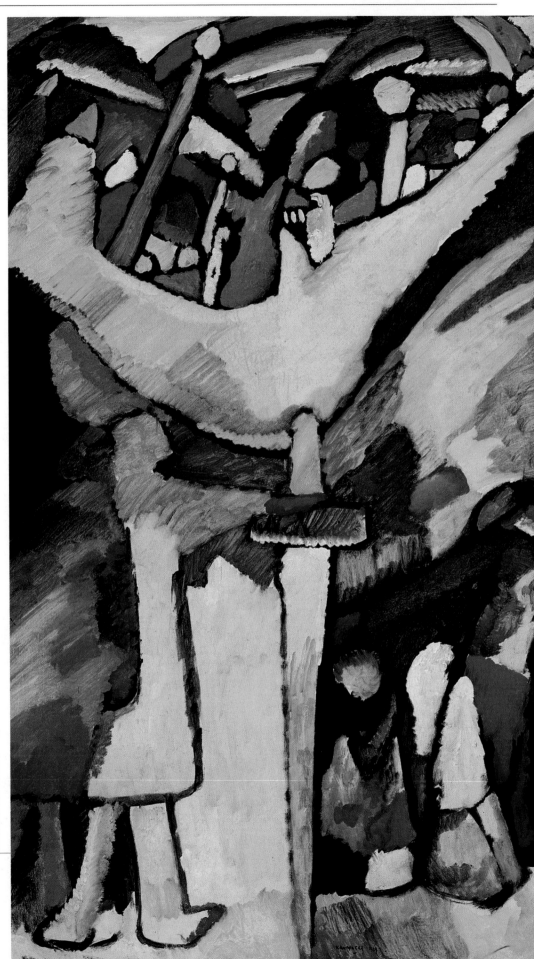

♦ LANDSCAPE WITH TOWER
(1908, Neuilly-sur-
Seine, private collection)
Influenced by the work
of Matisse, Kandinsky
elaborates the pictorial
drafting process, deforming
objectively seen forms.
The combinations of
colours which he uses, his
"chromatic chords", derive
from a harmonic system
which is more complex
than that of the Fauves.

♦ FRAGMENT
OF COMPOSITION II
(1910, private
collection)
Although
Kandinsky calls
this a fragment,
it is in fact an
autonomous work.
The painting
continues onto
the frame, as he
has begun to do
in his glass paintings.

♦ HOUSE IN MURNAU
(SUMMER LANDSCAPE)
(1909, Saint
Petersburg, Russian
State Museum)
Conceived and painted
during the happy days
of his stay in Murnau.
This oil painting on
cardboard shows traces
of French influence,
from the synthesism of
the Nabis to the
expressionism of the
Fauves. The colours
are strong and spread
widely on the canvas.

♦ IMPROVISATION VIII
(THE SWORD)
(1909, private collection).
This is the most
important painting of
1909. A yellow wall
around the city, a series
of domes, and a
horseman with a sword
of disproportionate
dimensions are the
themes of this painting.
This oil painting on
canvas is still figurative
in style. It could be a
guardian outside the
walls of Jerusalem.

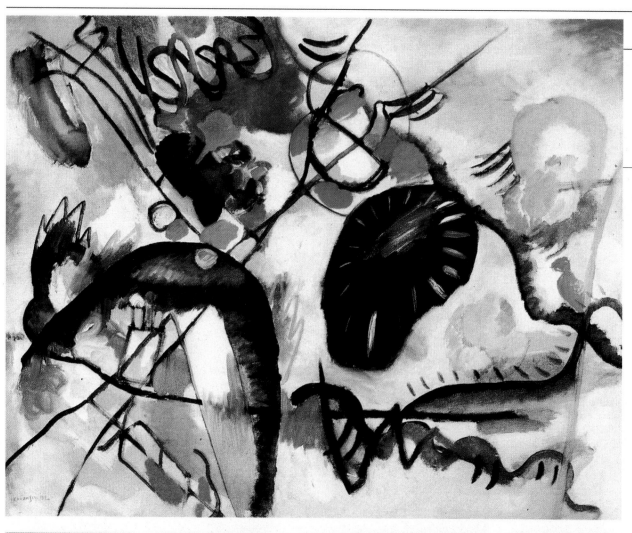

◆ BLACK SPOT 1
(1912, Saint
Petersburg, Russian
State Museum).
Kandinsky has
completely abandoned
all traces of
figurativism in his
paintings. All that
remains is the
suggestion of two trees
and the domes of two
church in the bottom
left. The harmony
of the vibrant colours
and the composition
of the surfaces follow
the principles of
dissonant music.
In this period
he becames a friend
of the composer
Arnold Schönberg,
the author of the
revolutionary *Manual
of Harmony* and inventor
of 12 note music.

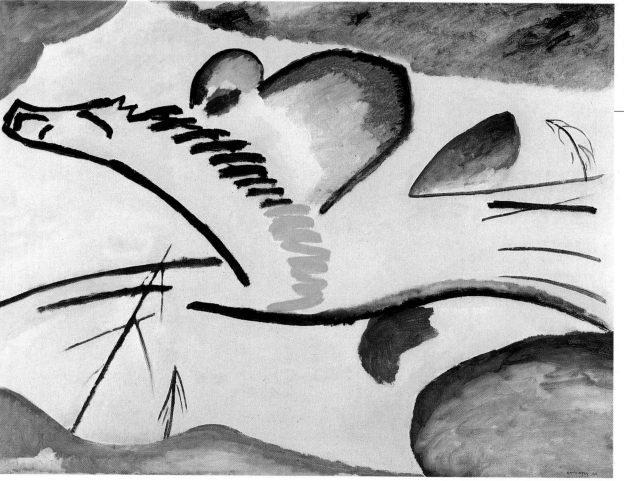

◆ LYRICAL
(1911, Munich,
Städtische Galerie im
Lenbachhaus).
It is Kandinsky himself
who chooses this image
to insert in the pages
of the *Blue Rider
Almanac*. Lyrical
is one of only a few
of his compositions
to be found between
the writings
of the almanac.
A horse in full gallop
with a rider bent
on its back can
be distinguished
in this painting.
In Indian mythology
the horse knows
the road which leads
to the sky. The theme
of Elijah ascending
into the sky in a horse-
drawn carriage is very
dear to Kandinsky.
He uses this theme in
many of his drawings
and paintings.

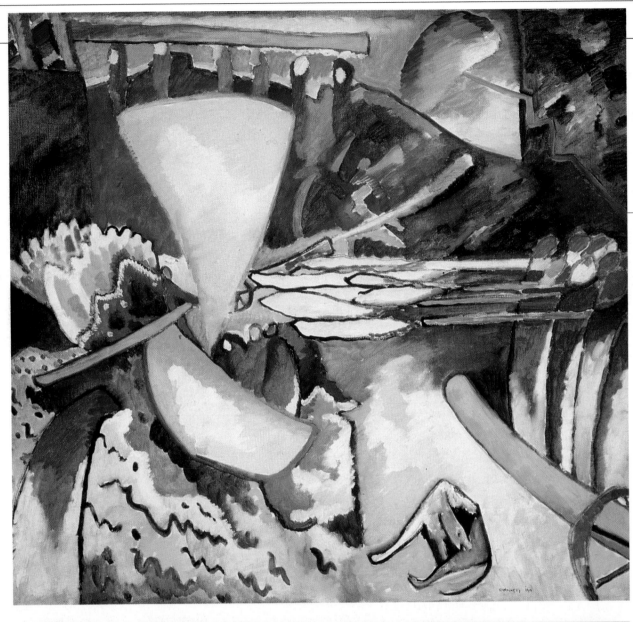

◆ IMPROVISATION XI (1910, Saint Petersburg, Russian State Museum). Kandinsky distinguishes between "impressions", "composition" and "improvisation". The spontaneity of the painting process allows the direct and immediate translation of coloured impressions from the "internal nature" of the subject. The selection of colours in the picture corresponds to the full gamut of emotions. There is yellow which "excites man and makes him restless (.....) resounding like an acute trumpet or the sound of a fanfare (....)".

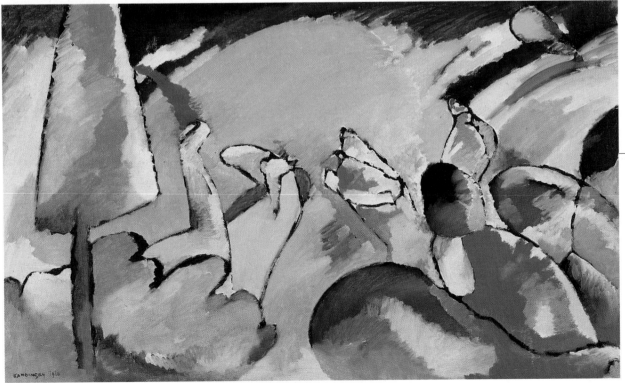

◆ IMPROVISATION XIV (1910, Paris, The Georges Pompidou Centre). At the height of his physical maturity Kandinsky produces paintings which are profoundly non-descriptive, not invoking associations. His "improvisations" are decisive works in their affirmation of abstractism. Wagner's *Lohengrin* is a font of inspiration at this important turning point. With this symphony Kandinsky recognises the chromatic force of graphic expression.

THE ANNULING OF HISTORY

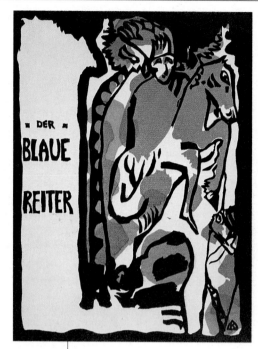

In 1911 Kandinsky and Franz Marc, who met the previous year, found a new group: *The Blue Rider (Der Blaue Reiter),* which together with the neoplasticism of Mondrian encourages abstractism in Europe. The negation of figurativism, and the annuling and reformulation of history coincide with Kandinsky producing paintings which consist of lines, shapes and pure colours. This avant-garde movement of which Marc, Macke, Klee and Kandinsky are members, distanced themselves from the deforming expressionistic attitudes of the German *Bridge (Die Brücke)* group, which remained figurative and was burdened with uncomfortable existential sentiments. The anarchic and contentious character of this group is reflected in their dark, tenebrous colours. The colours of Kandinsky and his circle, whose work is derived from impressionism and Fauvism, are quite different. The paintings are based on white, on light.

● The adventure of the *Blue Rider* group is brief. The winds of war sweep away the movement in 1914, dispersing its members. Franz Marc and August Macke lose their lives in battle and Paul Klee has not reached his full development when Kandinsky takes refuge in Russia. The most impassioned moment for the group is the publishing of the almanac which takes the name of the group, and the organisation of two exhibitions to which the most important artists of the European avant-garde are invited, Picasso, Rousseau, Delauney, Arp, Braque, Heckel, Kirchner, Gončarova, Malevič, and Nolde.

● *The Blue Rider Almanac* is one of the fundamental documents of modern aesthetics and the most characteristic expression of the artistic and cultural renewal taking place in the years preceding the First World War. Graphic contributions by Cézanne, Picasso, Matisse, Kandinsky, Marc, Macke and above all by Rousseau are included. The texts are dedicated to painting and music which have a dialectic relationship. The intention is to create a new art which leaves no traces of formal elements, an art which is left to run, like the rider on the cover, like the spirit.

◆ COVER OF THE ALMANAC "DER BLAUE REITER" (1912, Basle, Musée des Beaux-Arts, Cabinet des Estampes). The almanac is of large format and has colour prints. It is edited in Munich at Kandinsky's instigation. German and Russian painters and musicians collaborate. The oval photograph shows Kandinsky (in the front) in the period of the *Blue Rider*.

◆ THE BLUE RIDER (1903, Zurich, the collection of E.G. Bührle) Many paintings which have the rider as a subject can be found among Kandinsky's first works, among which is the small oil painting on canvas on the right. Below, a preparatory sketch for *The Blue Rider Almanac* (1911, Munich, Städtische Galerie im Lenbachhaus).

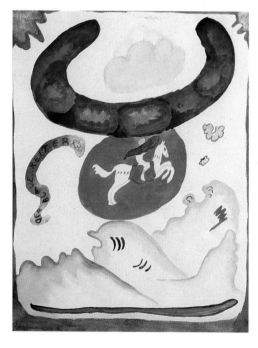

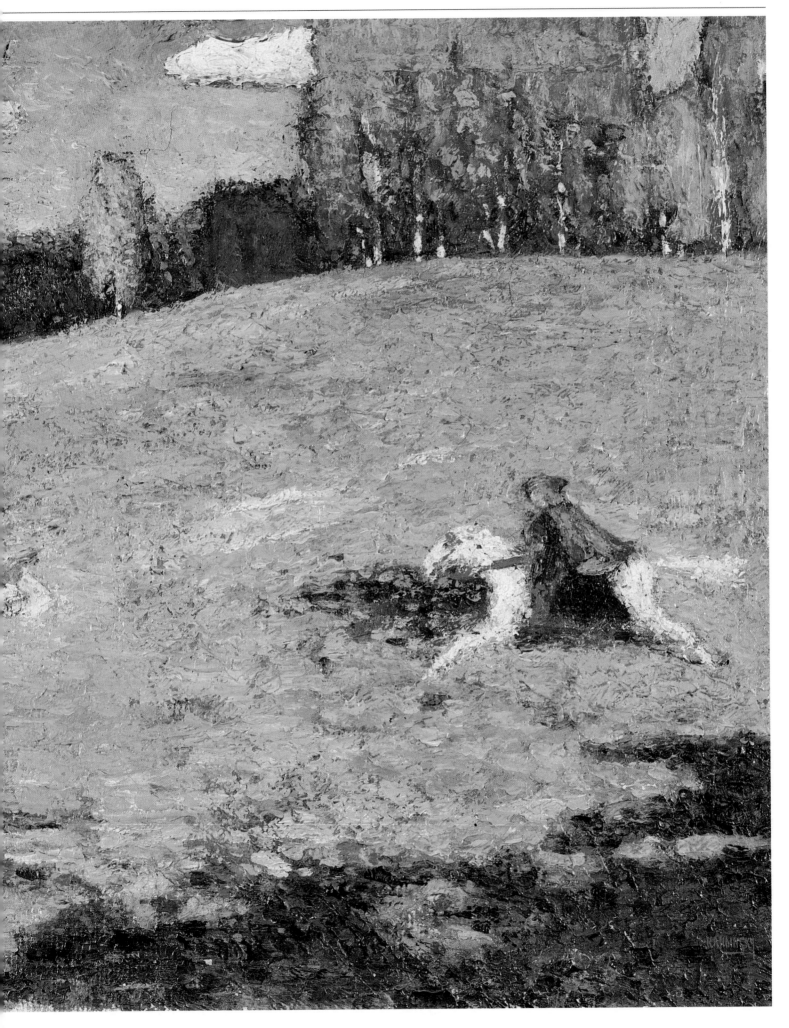

PRODUCTION: THE BLUE RIDER

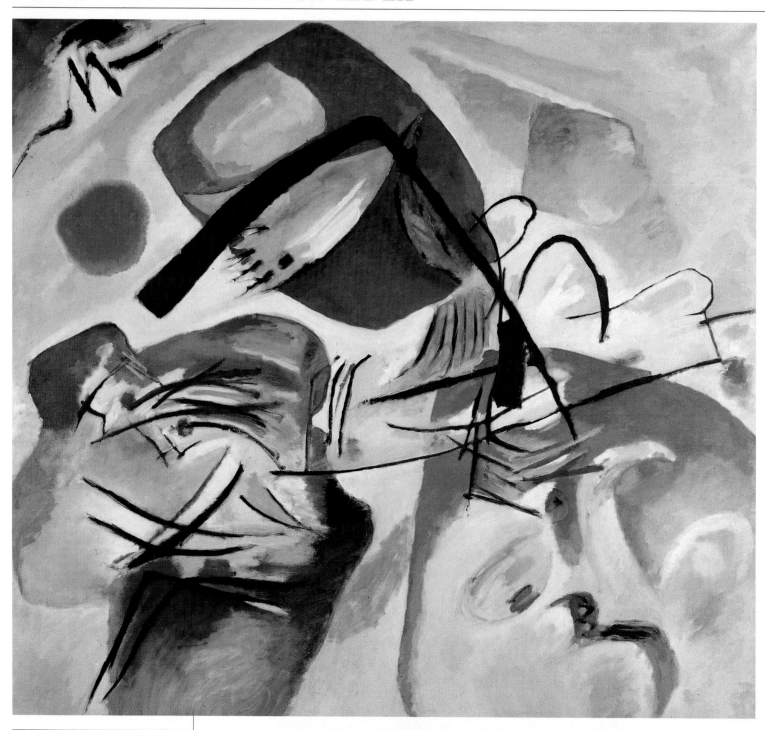

♦ WITH BLACK ARCH
(1912, Paris,
Georges Pompidou
Centre).
The work is conceived
at the height of the
abstract period.
Kandinsky abandons all
objective references and
gives a prominent role
inside the composition
to the colour black,
while reflecting on the
principles of unity and
harmony which
determine the
composition.

In his first writings,
Glimpses into the Past he
relates how in the
preceding years, while
sketching the hooves of
a horse with black
watercolour paint he
notices four large, dark
blots which he did not
intend to paint.
From that point he
abandons the use of
black, spread directly
onto the canvas, only
returning to it when his
means of expression
have reached maturity.

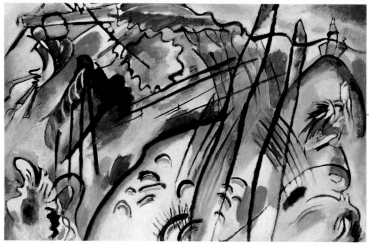

♦ IMPROVISATION
XXVIII
(1912, New York,
Guggenheim Museum).
The harmony
of colours in this
composition,
which vibrate
and stretch, follow
the principles
of dissonance which
Arnold Schönberg
is experimenting
with in music in this
period. Kandinsky
and the composer
become great friend.

28

◆ FRANZ MARC
Small Blue Horses
(1911, Hamburg,
private collection).
Marc collaborated
with Kandinsky
in the drafting
of *The Blue Rider
Almanac* and they
research new forms
of expression together.
The representation
of animals takes
on more and more
importance in Marc's
work until the point
when human figures
no longer appear.
The animal subjects
are always treated
in a non-traditional,
abstract manner
however.

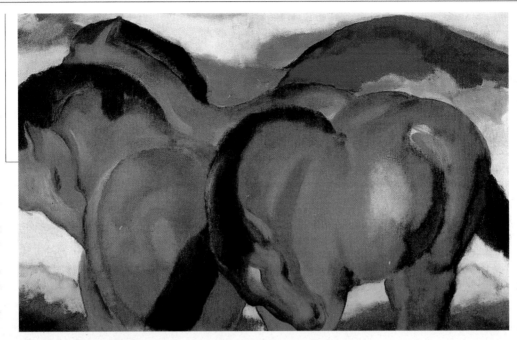

◆ AUGUST MACKE
Children at the Fountain
(1914, Bonn,
Sädtisches
Kunstmuseum)
Macke is part
of Kandinsky's
circle and of the avant-
garde movement
Die Brücke (The Bridge)
but his works
do not have
the social and
political spirit of the
German expressionists.
He has an idyllic
vision of reality
in the treatment
of his subjects.
As a soldier in the
great war and is killed
a few days after the
start of the conflict.

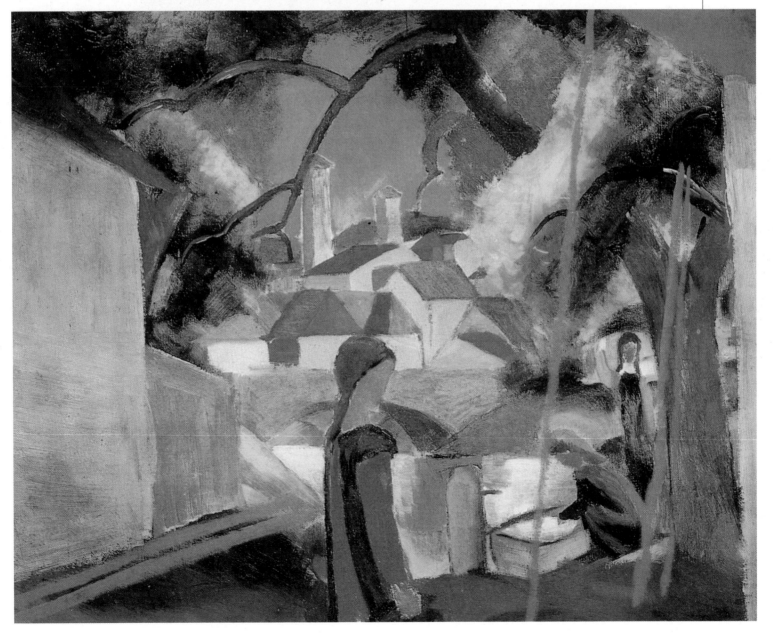

THE LEAP INTO THE FUTURE

Kandinsky is the first painter to complete the passage from the figurative, imitating reality, to the non-objective, the abstract. Symbolism and pointillism have already, at the end of the nineteenth century, brought about a transformation of the image, but no painter has dared to shake off all recognisable traces of the object being portrayed. Kandinsky embraces and personally elaborates the aesthetic elements which tend towards abstractism: including the symbolism and spiritualism of Russian culture, the primitivism of the Nabis movement in France, and the experimentation of the *Jugendstil* movement in Munich. These movements, through the progressive stylisation of form, emancipate painting from nature. The research on sinesthetic expression,

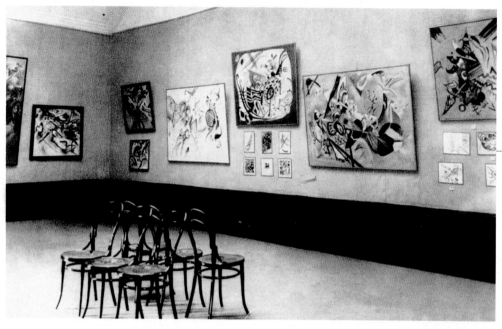

♦ IMPROVISATION XXXIV (ORIENT II) (1913, Russia, Kazan Museum) Between 1912 and 1914 Kandinsky manages to break into the American art world. His works, like this refined oil on canvas, are exhibited alongside those of Cézanne, Matisse and Picasso.

in which various sensory stimuli are superimposed, connecting colour and sound for example, is also important.

● Kandinsky is the first to discover the inner world. He investigates the resonances and the uncertain confines of the spirit. His quest is the discovery of an art which creates the conditions for contact with a profound reality, without leaving aside the influence of the outward appearance of the form. He is convinced that the search for the invisible which leads from abstractism must investigate both individual and universal space. The more that the organic form is subdued the more there is a need for an advanced form of abstractism.

● The work and experimentation of Kandinsky is not understood initially. He is accused of intellectual arrogance, and of having insufficient control over pictorial space. The reality is, in fact, that Kandinsky can take credit for projecting art into the land of opportunity at the forefront of modern culture.

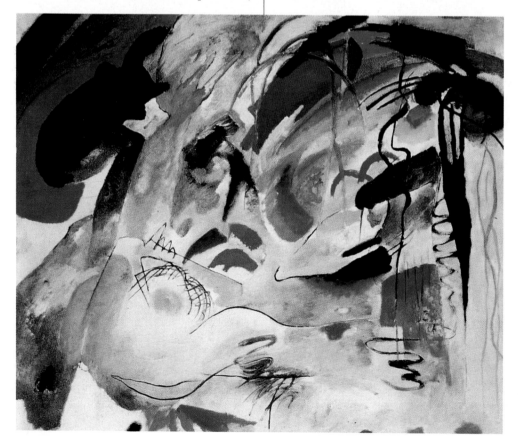

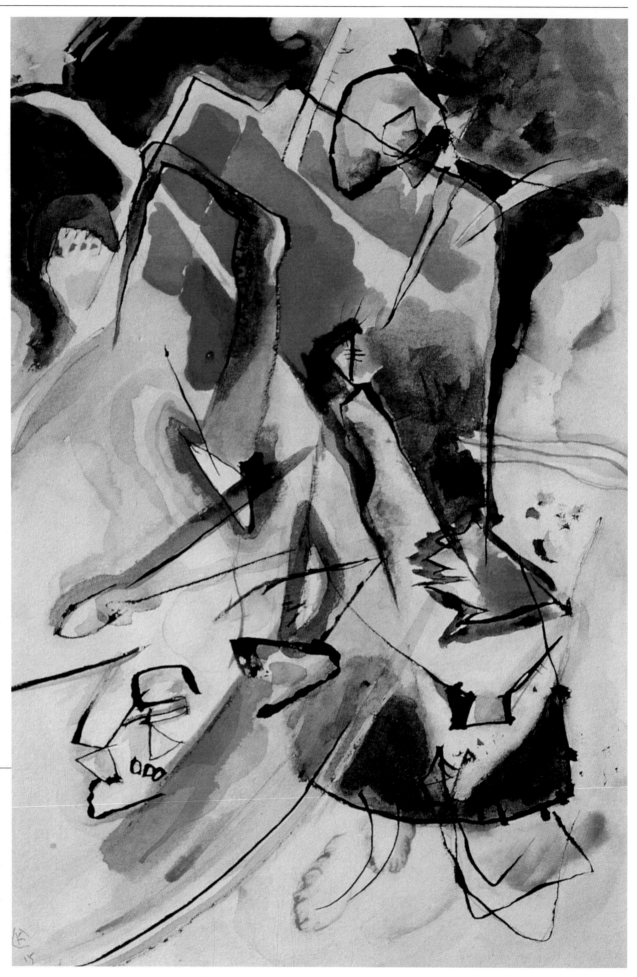

◆ THE XIX STATE EXHIBITION, MOSCOW
In this photograph from 1920 is a room of the XIX State Exhibition in Moscow. It is the second and last personal exhibition of Kandinsky's work in Russia. The painter presents his work under the banner of abstractism, in this, the period of the *Blue Rider.* He wishes to reaffirm his thesis of the "spirituality in art", against the ferocious criticism received, and reveal the movement away from figurativism which he has reached in his paintings.

◆ COMPOSITION (FEMININE FIGURE) (1915, Saint Petersburg, Russsian State Museum). Even though the human figure appears completely absorbed in the abstract signs and strokes, traces of the female form can be recognised in this watercolour. These are years of conflict in the world. Kandinsky is deeply distressed by the death of his fellow painters and takes refuge in the techniques of watercolour painting, abandoning oil painting. The rapid ink strokes clearly demonstrate his disturbed state during the war.

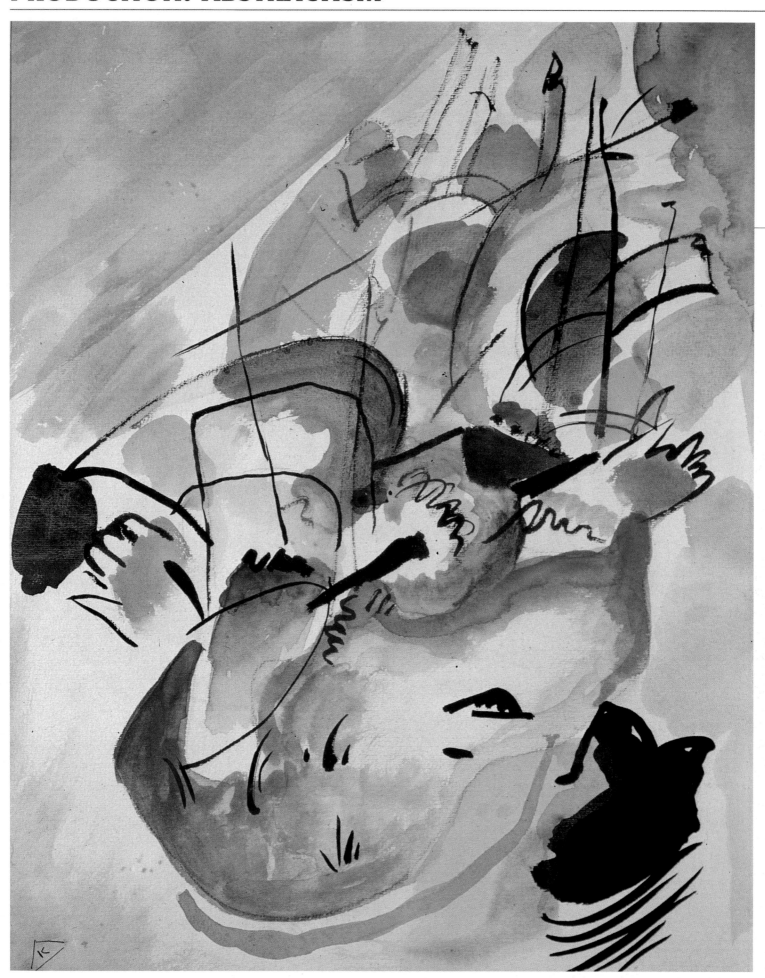

◆ ABSTRACT WATERCOLOUR (1910, Paris, The National Museum of Modern Art). According to the dates given by Kandinsky, this watercolour is of the year preceding his famous *First Abstract Watercolour* which is preserved in the Georges Pompidou Centre. This composition is much more articulate and demonstrates a higher degree of abstractness assimilated into the forms. The colours are more decisive and the non-figurative style is more certain. It is probably an error of dating on the part of the artist.

◆ IN THE BLUE (Düsseldorf, Kunstsammlung Nordrhein-Westfalen). Kandinsky's work has lost all connotations to natural elements in this stage of his development. The compositions are constructed with geometric forms and chromatic fields, becoming more and more articulate. The pictorial inquiries into abstractism are carried out alongside theoretical reflections and writings. Kandinsky publishes two texts on painting, *On the Spiritual in Art* in 1912 and *Point and Line to Plane* in 1926.

THE WEIMER YEARS AND DESSAU

In the summer of 1922 Kandinsky and his wife Anna move to Weimar in Germany, where since 1919 the Bauhaus School of Applied Art has been open. It is not an artistic academy in the accepted manner, but is a more modern institution of the first years after the war. Founded by the architect Walter Gropius, the Bauhaus foretells the future of art. Emphasis is placed on architecture and crafts, which are considered to be the solid foundation of any aesthetic procedure. According to Gropius, all the activities carried out in the school must have a higher aim, which is the construction of a collective work to which all contribute their particular craft. The teachers consist of a group of experienced technicians who are under the leadership of a master-craftsman. The artistic and creative components are guided by a master-artist.

● In 1922 Kandinsky becomes a teacher in the school, later becoming the vice-director. He is entrusted with the preparatory course "The Theory of Form". He has a fundamental role as a teacher as well as his work in the wall painting studio. His wife recounts his great enthusiasm for teaching, dedicating hours to the preparation of his lessons. His notebooks, which he updated daily, are all that remains as a testament to his teaching activity. His pupils remember the master's great didactic skill. He taught them not only the techniques of painting but how to see beyond the forms and understand the meaning.

● The Bauhaus years signal a change in style for Kandinsky. Despite his involvment in the engaging communal life of the school, he still manages to reconcile both teaching and painting. He abandons the nebulous suggestions of symbolism and the emotional expression of liberally applied fields of colour. He studies the composition of geometrical shapes. His work centres on the analysis of points, "the only link between silence and the word". He also works on the aesthetic relationship between painting and music.

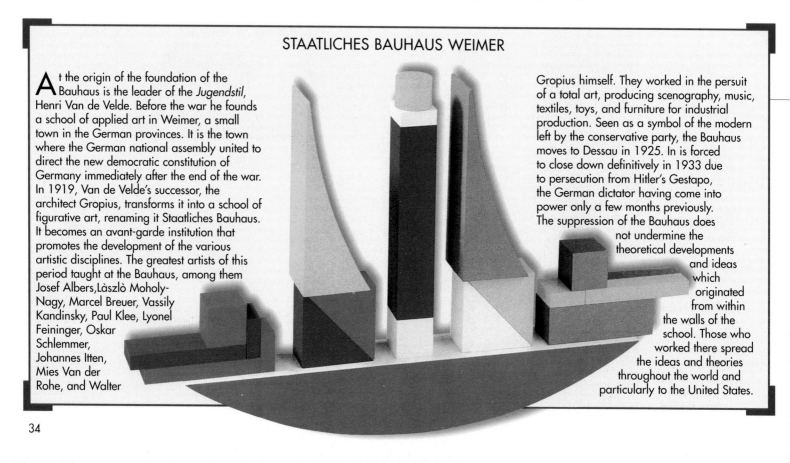

STAATLICHES BAUHAUS WEIMER

At the origin of the foundation of the Bauhaus is the leader of the *Jugendstil*, Henri Van de Velde. Before the war he founds a school of applied art in Weimer, a small town in the German provinces. It is the town where the German national assembly united to direct the new democratic constitution of Germany immediately after the end of the war. In 1919, Van de Velde's successor, the architect Gropius, transforms it into a school of figurative art, renaming it Staatliches Bauhaus. It becomes an avant-garde institution that promotes the development of the various artistic disciplines. The greatest artists of this period taught at the Bauhaus, among them Josef Albers, Làszlò Moholy-Nagy, Marcel Breuer, Vassily Kandinsky, Paul Klee, Lyonel Feininger, Oskar Schlemmer, Johannes Itten, Mies Van der Rohe, and Walter Gropius himself. They worked in the persuit of a total art, producing scenography, music, textiles, toys, and furniture for industrial production. Seen as a symbol of the modern left by the conservative party, the Bauhaus moves to Dessau in 1925. In is forced to close down definitively in 1933 due to persecution from Hitler's Gestapo, the German dictator having come into power only a few months previously. The suppression of the Bauhaus does not undermine the theoretical developments and ideas which originated from within the walls of the school. Those who worked there spread the ideas and theories throughout the world and particularly to the United States.

◆ THE TEACHERS
OF THE BAUHAUS
On the roof of the
Bauhaus are gathered
its teachers, masters
of the art of this
century. The Bauhaus
was built from a design
by Walter Gropius. In
the photograph, from
the left, are Josef
Albers, Hinnerk
Scheper, Georg Muche,
Làszlò Moholy-Nagy,
Herbert Bayer, Joost
Schmidt, Walter Gropius,
Marcel Breuer, Vassily
Kandinsky, Paul Klee,
Lyonel Feiniger,
Gunta Stolzl, and
Oskar Schlemmer.

◆ ON WHITE 2
(1923, Paris,
The Museum of
Modern Art).
Geometric elements
make their appearance
in Kandinsky's
work during his period
at the Bauhaus.
Perpendicular lines
which cut circles
perfectly in half
accompany an
astute use of colour.

◆ ALMA BUSCHER
Construction Game
(1924)
The wooden toys
of Alma Buscher are
among the products
from the Bauhaus
which have the greatest
success. The artist
designs simple,
modern, well-
proportioned toys,
rejecting the aesthetics
of children's fairy tales.

◆ SEVERAL CIRCLES
(1926, New York,
Guggenheim Museum).
Kandinsky dedicates
more and more time
to circular forms,
which he developed
a preference for during
his period at the
Bauhaus. This oil
painting on canvas is
his most important
painting of that period.

◆ JOOST SCHMIDT
Bauhaus Poster
(1923)
This poster
was produced
by Schmidt for
the Bauhaus exhibition
of 1923. The poster
uses geometrical
motifs as in the work
of Kandinsky.
During his time
in Weimar Schmidt
is influenced by
ideas on the synthesis
of art developed
by Gropius.

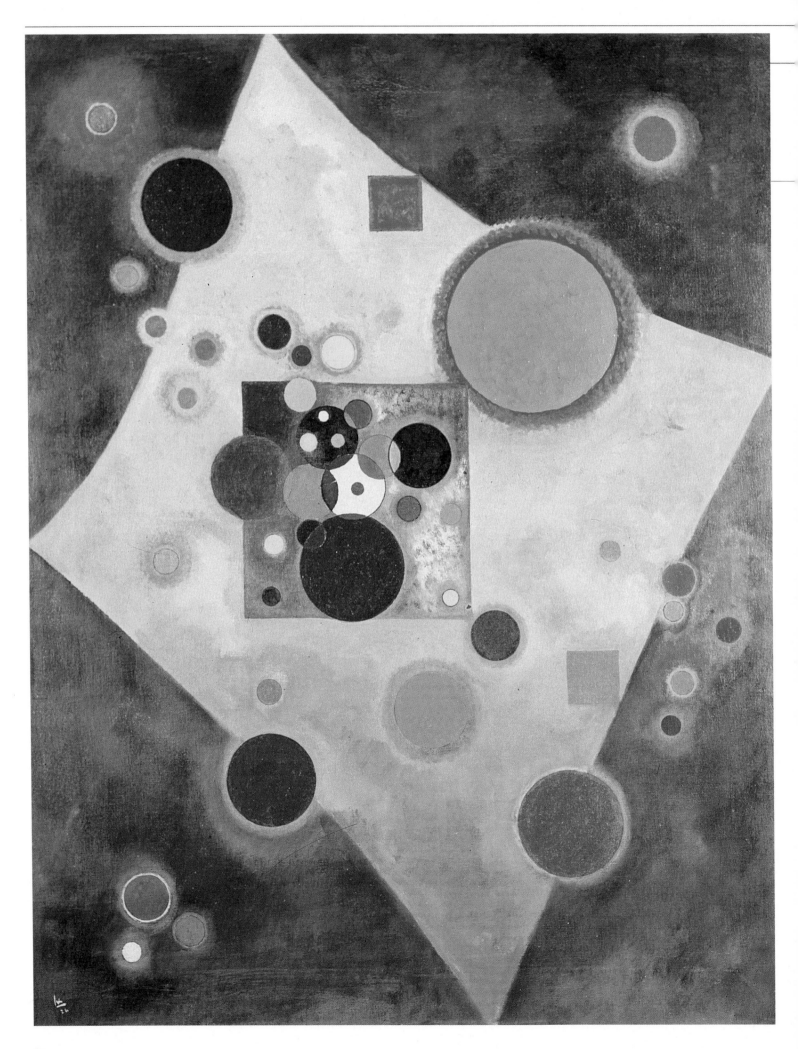

◆ PAUL KLEE
New Harmony
(1936, New York, The
Guggenheim Museum).
The Swiss artist, who
is a friend of Kandinsky,
is among the modern
artists most involved
in solidifying the
relationship between
theory and practice.
He is a teacher
at the Bauhaus at
the same time as the
Russian master. He also
produces work which
surpasses objective
reality. Through
meticulous research,
both formal and
speculative, he reaches
a state of abstraction.

◆ YELLOW-RED-BLUE
(1925, Neuilly-sur-
Seine, Nina
Kandinsky collection).
In his many years
as a teacher,
Kandinsky
is in close contact
with many talented
and stimulating
students who suggest
new themes
for his investigations
into abstractism.

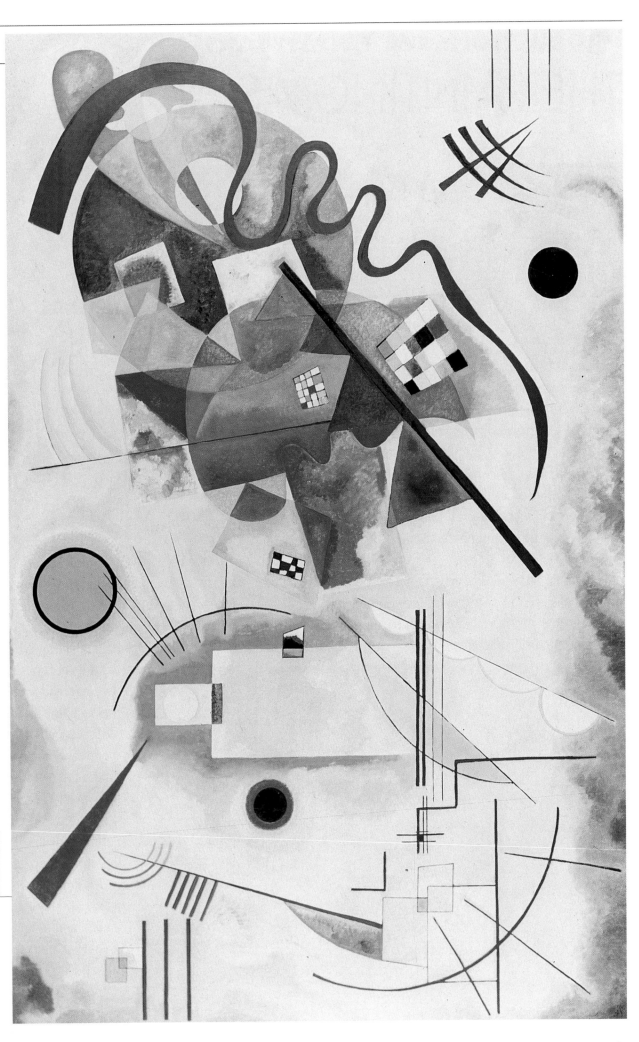

THE PAINTING AS HOPE

After the closure of the Bauhaus, Kandinsky abandons Germany, which is by now in the hands of Hitler. He decides to move to Neuilly-sur-Seine, near Paris, where he lives until his death in 1944. Paris is the capital of the art world at this time and attracts Europe's most creative personalities. It is the cradle for Surrealism, a scandalous aesthetic provocation. The city does not welcome Kandinsky warmly however. The French press almost mistakes him for Marc Chagall. The German press, on the other hand, associate his splendid colours with exotic Russian folklore. He passes his days walking in the Bois de Boulogne and working until dusk, never painting in artificial light. In the evening he sometimes draws or works on his theoretical texts.

● This final phase of his artistic production is designated "lyrical abstraction". He commences a new, fertile phase which is characterised by fluid images, mobiles, archetypal symbols, and brilliant colours. He acquired a perfect control

of his medium and an absolute knowledge of space during his spell teaching at the Bauhaus. His compositions consist of assymetrical shapes, dense and appearing to shatter. It is like stepping into an unknown future. Decorative etchings from Asia and Latin America and antique Russian icons, combine with references from the works of the two surrealist painters with whom he keeps company, Arp and Miro.

● In his final paintings, biomorphs appear more frequently: fantastic, enigmatic insects which flutter weightlessly in space. He never loses sight of the importance of colour, the dynamic relationships and the tension within the whole composition. He develops his work and ideas from the Bauhaus period, deepening his refined sense of space and abandoning geometric motifs. His final works are replete with these new, magical creatures, a biological fantasy born from the horrors of the second world war.

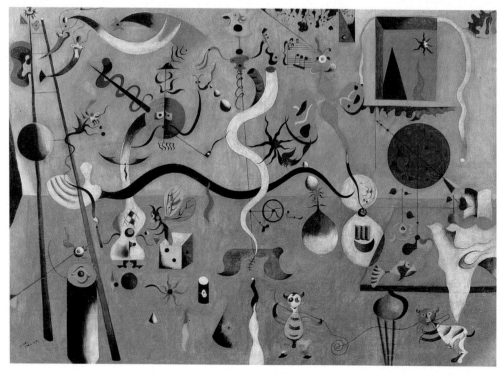

◆ HANS (JEAN) ARP
Configuration
(Basle, Kunstmuseum).
Kandinsky meets
the Alsatian
Hans Arp in Paris
during the final
phase of his artistic
production.
The artist once again
favours soft, fluent
shapes which are
vaguely suspended
in the compositions.

◆ DIVISION-UNITY
(1934, Tokyo, Seibu
Museum of Art)
Small, capricious,
polychrome
figures fluctuate
within a regular
grill which covers
the entire
surface of the
composition.

◆ BLUE OF THE SKY
(1940, Paris, Georges
Pompidou Centre).
Meeting Joan
Miro influences
Kandinsky's work.
Biomorphs which
seem to be alive
and continually
changing are
introduced into
his work. These
biomorphs,
which look like
larvae, insects
suspended in space,
appear to come from
the profound depths
of the artist's soul.

◆ JOAN MIRO
Harlequin's Carneval
(1924-25, Buffalo,
Albright-Knox Art
Gallery).
The Catalan painter
says he wants
to "assassinate
painting" with
his ironic use
of geometry.

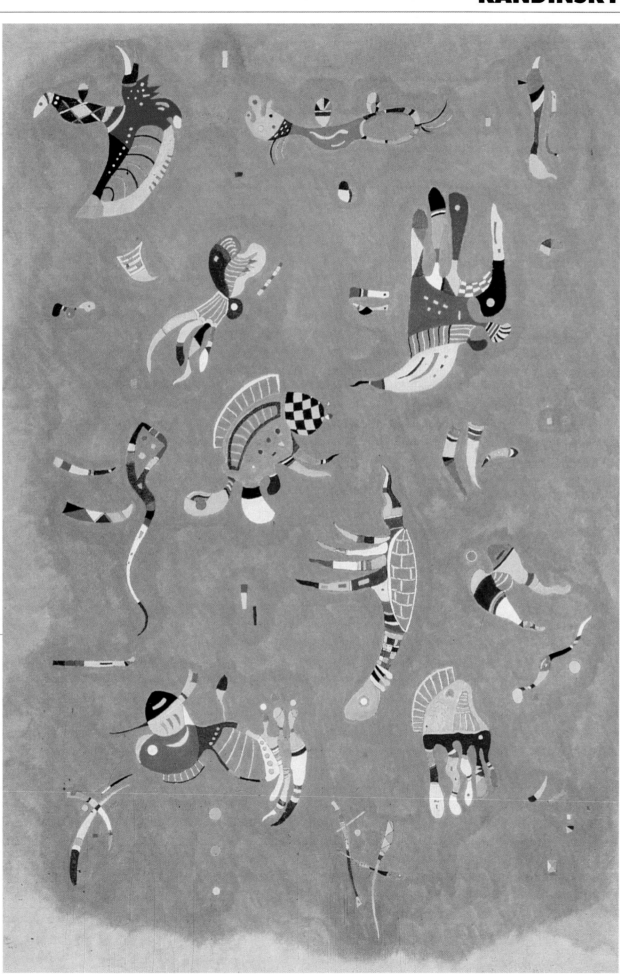

THE RUSSIAN SPIRIT IN EUROPE

Vassily Kandinsky is born in Moscow on the fourth of December 1866. His father is of Siberian origin with Mongolian ascendency and his mother is from Moscow and has German blood. In this period Dostoevsky publishes *Crime and Punishment* and Tolstoy sends his volumes of *War and Peace* to the printers. Borodin and Mussorgskij are asserting themselves in the domain of music.Towards the end of century Russian painters feel the influence of Europe and their paintings are celebrations of nature.

● The final thirty years of the nineteenth century is inaugurated with the revolution of impressionism in painting. In 1874, in the photographic studio Nadar, a group of artists who work *en plein air* exhibit their work for the first time, breaking with the accademic traditions of the *Salons. Art Nouveau,* an essentially decorative style, enjoys great popularity at the turn of the century.

● Constructions in metal become more and more popular after the exhibitions of 1878 and 1889. The Eiffel Tower, constructed in 1889, displays the technical advances of engineers achieved at the time.The use of steel in place of iron hails the arrival of first sky scrapers in New York.

Adolf Loos, the Austrian rather of rationalist architecture publishes an influential essay entitled *Ornament and Crime.*

● In the Russia of 1905, a revolution of the bourgeoisie, industrialists and intellectuals prepares the way for the overturn of the Russian autocracy. In 1917 the Bolshevic forces, under the leadership of Lenin, seize power and withdraw Russia from the war, which has been tearing Europe apart for three years.

● The first feature films are produced. Charlie Chaplin's films, *The Vagabond* of 1916 and *Gold Fever* of 1926 achieve international fame.

● The Dadaist movement is born in Zurich in 1915 with the works of Hans Arp and Tristan Tzara. The group *De Stijl,* founded in Holland by Théo Van Doesburg and Piet Mondrian develops a concept of art and architecture that investigates spatial equilibrium based on the use of straight lines, right angles, and primary colours. In Europe the architects Walter Gropius, Ludwig Mies van der Rohe and Le Corbusier, convinced of the necessity to design functional and linear buildings, use new materials such as cement and glass, creating a new style.

● The first Volkswagen "Beetle", designed by Porsche at Hitler's request, is constructed in 1938. Kandinsky's canvases are confiscated, maltreated and burnt during the Nazi regime as examples of degenerate art. Kandinsky becomes ill with cerebral sclerosis at the end of 1944. Hoping to regain his health, the artist makes projects for new works and looks forward to the arrival of Christmas. He dies, however, at eight o'clock in the evening of the 13th of December.

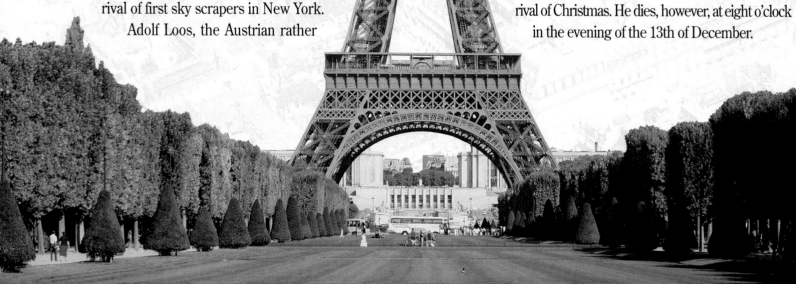

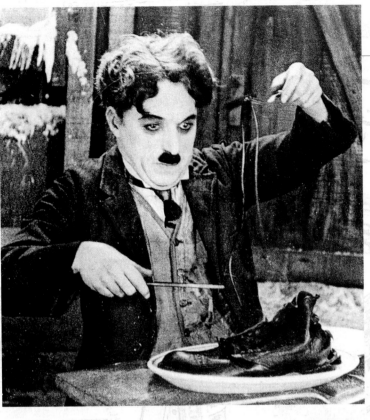

♦ CHARLIE CHAPLIN
A scene from the film *Gold Fever* of 1926. The famous Charlot is the leading character in this success of the silent cinema.

♦ OSKAR KOKOSCHKA
Portrait of Adolf Loos (1909, Berlin, Nationalgalerie SMPK). The architect and architectural theorist, Adolf Loos, is the father of modernism and is a forerunner of rationalism. He becomes a patron of the young Austrian painter Kokoschka, who painted this portrait.

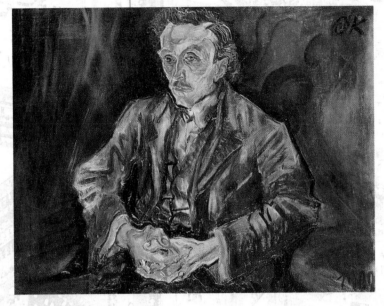

♦ THE EIFFEL TOWER
The 300 meter high Eiffel Tower (as seen on the previous page) becomes a symbol of the city of Paris. It is a monument to an avant-garde technique which allows great flexibility and resistance with a minimum of weight.

It is designed and constructed by Alexandre-Gustave Eiffel in 1889 on the occasion of the World Show in Paris. In the top right is Kandinsky's membership card of the Bauhaus of Dessau.

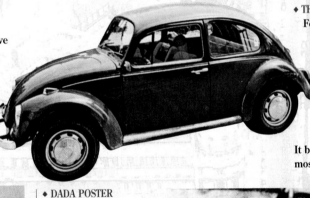

♦ THE BEETLE
Ferdinand Porsche designed the famous "Beetle" for the German automobile company Volkswagen. It become the most famous and most widely dispersed car in the world. Adolf Hitler coined the name Volkswagen, which literally means "people's car", he also designed the logo. Porsche founded his own automobile company in 1947.

♦ DADA POSTER
(1920, Paris, Salle Gavenau). The Dada movement is born in Zurich in 1915, the greatest intellectuals of the post-war era participate. The name *Dada* has no meaning, it is assigned to the movement quite casually, for its pleasing sound.

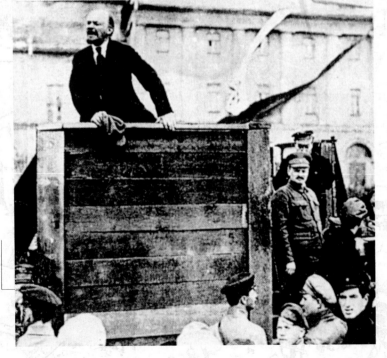

♦ NIKOLAI LENIN
The communist revolutionary speaks to a Moscow gathering in 1919. Lev Trotsky, wearing a moustache, can be recognised at the side of the platform.

THE PAINTING OF SIGNS

Kandinsky's work signals the start of a revolution which involves the whole of twentieth century art. The image is free from its relationship with the visible world. In opposition to pragmatic bourgeois culture, art is deemed to be a means of psychological and emotional expression. It is the revolt of the individual against narrow intellectualism and the realism of the market. Kandinsky's works, *On the Spiritual in Art* and *Point, and Line to Plane* published in 1911 and 1926 are fundamental to the understanding of this artistic creed.

● The relationship between colour and geometric shapes in his abstract works, which are free of symbolic meaning, will be studied by exponents of kinetic and visual art in the 1970s. Kandinsky's games, with colours suspended in space, are reinterpreted by the American sculptor Alexander Calder. The sculptor combines *farber* (colour) and *ludens* (play) in the creation of devices designed only for entertainment. The viewer is distracted from the reality of the material which is used, which is in fact mostly metal sheets and rods.

♦ "ON THE SPIRITUALITY IN ART" (In the top left of the page are details of the cover). In 1911 Kandinsky publishes *Über das Geistige in der Kunst*, the fundamental text of abstractism in the nineteen fifties and sixties. *Mobile* of Alexander Calder (1958, Milan, Galeria il Naviglio). A suspended sculpture, it is made of sheet metal, rods and tubes.

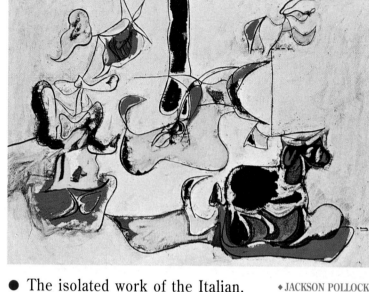

♦ JACKSON POLLOCK *Cathedral* (1947, Dallas, Museum of fine Arts). Pollock is the principle exponent of American action painting. Above, *Garden in Sochi* (1941, New York, Museum of Modern Art), by the Armenian painter Arshile Gorky.

● The isolated work of the Italian, Osvaldo Licini, is influenced by Kandinsky's geometric motifs. Elements of Miro and Klee, both of whom were friends of Kandinsky, are mixed. American culture is infiltrated with the work of artists who are fleeing nazi persecution. America becomes the repository of Kandinsky's achievements in abstractism. Elements of abstractism blossom in the action painting movement, in which signs, lines, and masses of colour are spontaneously liberated through movement. In the same way that Kandinsky 's paintings are inspired by musical harmonies, the exponents of action painting create their work to the tangled sounds of jazz, in which each instrument makes its own melodic and rhythmic drawing.

● Kandinsky's work after 1920 appears to be influenced by the work of Malevič, Klee and Mondrian. His refined sense of colour never wanes however, the elements of his compositions are always in poetic accord. Kandinsky trusts his three close friends with aesthetic inquiries and ethical projects.

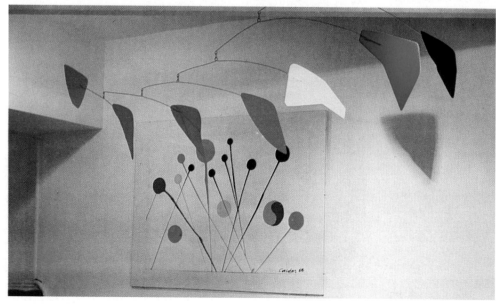

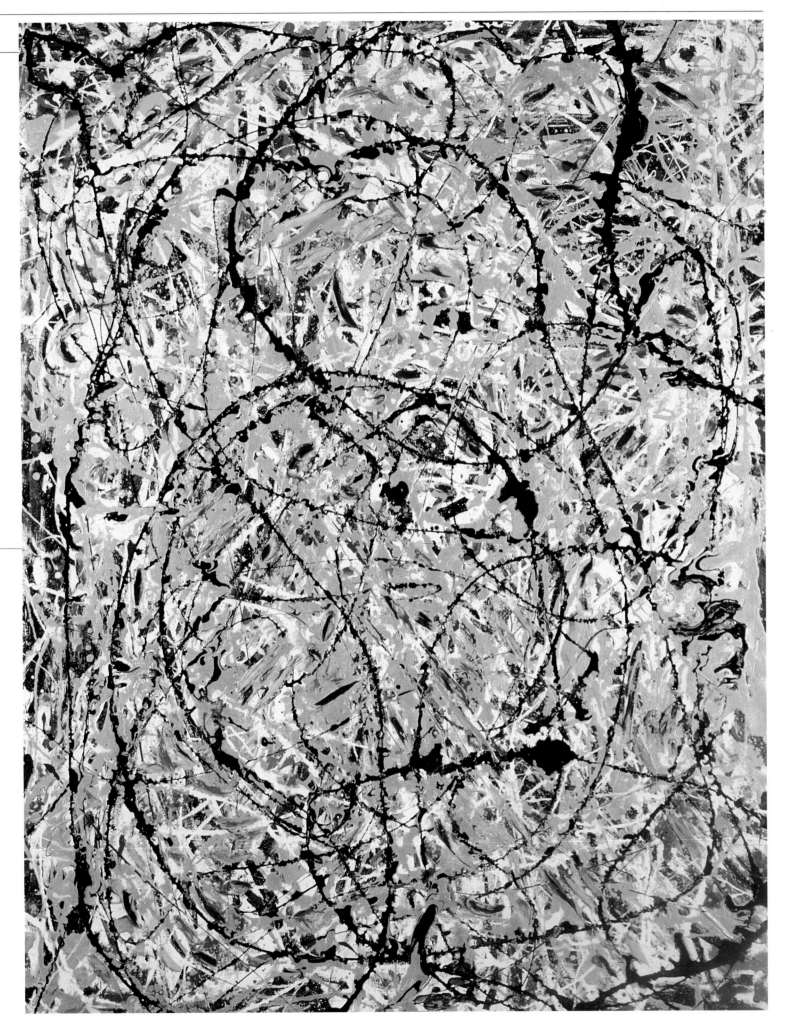

THE ARTISTIC JOURNEY

For a vision of the whole of Kandinsky's production, we propose here a chronological reading of his principal works.

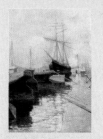

◆ THE PORT OF ODESSA (1896-98)

In Kandinsky's first oil painting, which is preserved in the Tre'tjakov Gallery in Moscow, a refined and meditated sense of colour is displayed. The light diffuses uniformly and naturally, as in the Nordic tradition. The shadows, especially in the use of dark colours, bring to mind the style of Rembrandt and his circle.

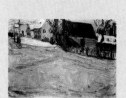

◆ URBAN LANDSCAPE (1902-03)

This oil painting on cardboard, which is in the Museum of Art in Odessa is from the master's first figurative phase. He uses a spatula to spread the colour and to create the landscape. These works, which are decisively simple, remain at the quick sketch stage. The drafting with the spatula is such that it follows the form of the object being depicted, oblique for the roofs and horizontal for the fields.

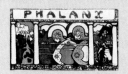

◆ THE *PHALANX* POSTER (1901)

Kandinsky produced this colour lithograph for the first *Phalanx* exhibition. It is preserved in the Städtische Galerie im Lenbachhaus in Munich. The formation of this artistic association dates to the protest against the jury of the Accademy of Art, the jury still favouring paintings which are formal and figurative.

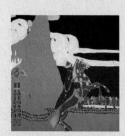

◆ THE HORSEMAN AND THE PRINCESS (1902)

The period in Munich is extremely productive. Kandinsky, influenced by the *Jugendstil* movement, produces this work, which has an ornamental character. It is half way between Russian culture, with its mysticism and fairytales, and Western culture. A swift and expressive pictorial technique is used, and with its characteristic use of widely spread colours, this painting has a similarity to oriental icons.

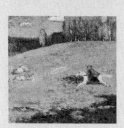

◆ THE BLUE RIDER (1903)

This painting is in the E.G. Bührle collection in Zurich. It is one of the first paintings of Kandinsky which have a horse and rider as a theme. A long series of paintings on similar themes are produced in the following years. The avant-garde movement founded by the Russian artist takes the name *The Blue Rider* in fact.

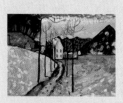

◆ WINTER LANDSCAPE I (1909)

The paintings from the Murnau period have an experimental character. Kandinsky assumes a new attitude towards nature. By this time his usual style of painting does not stretch his ability, it is too indulgent. To escape an artistic routine he often paints with his left hand. He moves away form the spatula technique, but continues to prefer the spontaneity of the sketch.

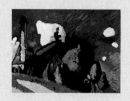

◆ LANDSCAPE WITH TOWER (1908)

Kandinsky is influenced by the canvases of Matisse, which he sees in the Paul Cassirer Gallery in Berlin in 1908. He elaborates and refines his pictorial drafting process, deforming objective vision, the criteria being non-descriptive. His chromatic chords are born from a harmonic system which is more complex than that of the *Fauves,* approaching that of the German expressionists.

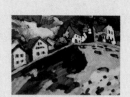

◆ HOUSE IN MURNAU (SUMMER LANDSCAPE) (1909)

This oil painting on cardboard was produced in the happy days of his stay in Murnau. The painting is now in Saint Petersburg. The painting has suggestions of French painting, from the *Nabis* to the expressionism of the *Fauves.* The decisive contours are similar to cloisonism, a technique which synthesises forms enclosed within clear black contours, the colours are flat and homogeneous.

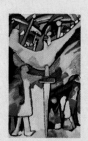

◆ IMPROVISATION VIII (THE SWORD) (1909)

It is the most significant painting of this year. It is now kept in a private collection. A yellow wall around the city, a series of domes close together, and a horseman with a sword of disproportionate dimensions are the subjects. This oil painting on canvas is still figurative in character. It has been hypothesised that the painting is portraying a guardian outside the walls of Jerusalem.

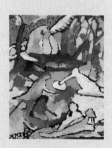

◆ FRAGMENT OF COMPOSITION II (1910)

Despite the fact that Kandinsky calls this a "fragment", this oil painting on cardboard is in fact an autonomous work, which can stand alone. The painting continues onto the frame, a practice which he has begun in his glass painting, which is part of his artistic production during his time in Murnau, from 1909-10.

◆ NUDE (1910)

This watercolour on light grey cardboard is now in the Städtische Galerie im Lenbachhaus in Munich. He utilises a style of rapid, decisive lines which are parallel and close together. This is repeated in the light, dynamic painting of his early abstract period. He is moving more and more towards the non-objective, towards a negation of the form.

◆ STUDY FOR IMPROVISATION VII (1910)

This oil painting on cardboard, which is in the Yale University Art Gallery, New Haven, is evidence of The development of Kandinsky's towards the disintegration of form. This matured during his stay in Murnau. The painting is not understood by the public of that period, the reaction being one of perplexity in front of the a painting which is not figurative and does not describe a real subject.

◆ THE SOUND OF TRUMPETS (1910-11)

This painting can be found in the Städtische Galerie im Lenbachhaus, where a large part of Kandinsky's work can be seen. This painting is evidence of the importance of music to Kandinsky's work. His abstract paintings develop through a form of musical improvisation, which is capable of communicating sensation without needing a descriptive support.

◆ PAINTING WITH A CIRCLE (1911)

This composition can be found in the Museum of Art of the Republic of Georgia in Tiblisi. Kandinsky has always attributed a great historical value to this, his first abstract oil painting. In fact, in his writings he never mentions his watercolour paintings. The fame of this work is owed to his wife Nina who spread the word all around the world.

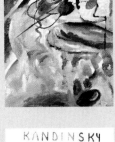

◆ COVER OF BOOKLET FOR AN EXHIBITION OF ABSTRACT ART (1911)

Kandinsky organises an exhibition of his non-figurative works and publishes a booklet, the cover demonstrates his graphic technique. Opposed by the public at the time, the abstract work of the master becomes the starting point for all non- figurative American artists in the nineteen fifties.

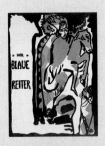

◆ COVER OF *DER BLAUE REITER* (1912)

The almanac, of large format and with colour illustrations, is edited in Munich in 1912. Its birth is due to Kandinsky's initiative. The collaborators are German and Russian painters and musicians, protagonists of the historical avant-garde of the beginning of the twentieth century. This sheet is preserved in the Musée des Beaux-Arts in Basle.

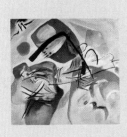

◆ WITH BLACK ARCH (1912)

This work is created at the peak of the abstract period. Kandinsky abandons all objective references and assigns a prominent role within the composition to the colour black. The use of black, spread evenly on the canvas, is later abandoned for several years. It returns only when the artist at his full maturity, when the artist is reflecting on the principles of unity and harmonic composition.

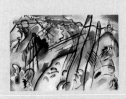

◆ IMPROVISATION XXVIII (1912)

This painting is in the Guggenheim Museum in New York. The work is organised around the harmony of colours, which vibrate and stretch within the composition, according to the principles of dissonance. Arnold Schönberg is experimenting on similar themes in music at this time. Kandinsky and Schönberg become great friends. The composer publishes his *Manual of Harmony* in 1911.

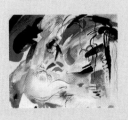

◆ IMPROVISATION XXXIV (ORIENT II) (1913)

Between 1912 and 1914 Kandinsky attains success in America. His compositions, like this refined oil painting on canvas, which is now in the Museo Kazan' in Russia, are exhibited alongside the works of Cézanne, Matisse, and Picasso. He enters the tight circle of those artists who are the greatest exponents of European art of the twentieth century, he is one of the masters of modernism.

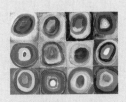

◆ STUDY: COLOURS, SQUARES, AND CONCENTRIC RINGS (1913)

When the majority of residual figurative elements disappear from his compositions and abstractism is a part of his normal artistic production, Kandinsky dedicates himself to the investigation of chromatic fields. He experiments with colour combinations. This work is in the Städtische Galerie im Lenbachhaus in Munich.

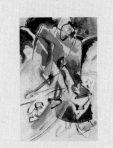

◆ COMPOSITION (FEMININE FIGURE) (1915)

Although the human figure appears completely absorbed by judiciously composed abstract signs and rapidly drawn lines, traces of the female form can be distinguished within the work. Kandinsky is deeply distressed by the death of two of his fellow painters. He takes refuge in the techniques of watercolour painting, becoming completely absorbed to the point of obsession.

◆ SKETCH FOR A WALL PAINTING (1922)

This sketch can be found in the National Museum of Modern Art in Paris. It is a magnificent example of wall painting, which Kandinsky practiced during his years working as a teacher at the Bauhaus. The teachers of the school theorize and practice the aesthetic synthesis of the total work of art. The complete work of art is produced by utilising all contemporary artistic disciplines.

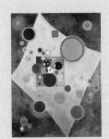

◆ PINK ACCENT (1926)

The circle takes on a predominant role in Kandinsky's painting of this period. The allusion to planets and constellations reflects the master's passion for astronomy. This is found in his paintings right from the beginning, *The Comet* of 1900 is an example. This painting can be found in the Georges Pompidou centre in Paris.

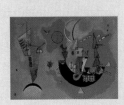

◆ FOR AND AGAINST (1929)

It is the first of Kandinsky's paintings acquired by Solomon Guggenheimer, today it is the property of the Thomas Gallery in New York. By this stage in his artistic development the forms and colours in this oil painting on cardboard obey their own laws. It is far removed from the symbolism in the artist's first landscapes paintings.

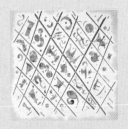

◆ DIVISION-UNITY (1934)

This composition is preserved in the Seibu Museum of Art in Tokyo. It is from the final phase of the painter's artistic production. Small, capricious, polychrome figures fluctuate within a regular grill which covers the entire surface of the composition. The small creatures in the paintings of Miro are brought to mind.

◆ BLUE OF THE SKY (1940)

From when Kandinsky meets the Spanish painter Miro, he introduces biomorph motifs into his paintings. They seem almost alive and to continually change. These biomorphs which look like larvae, insects suspended in space, appear to come from the profound depths of the soul, belonging uniquely to the artist.

TO KNOW MORE

These pages contain: some documents useful for understanding different aspects of Kandinsky's life and work; the fundamental stages in the life of the artist; technical data and the location of the principal works found in this volume; an essential bibliography.

DOCUMENTS AND TESTIMONIES

"We want that which is living"

Below is a quote from the first edition of the Blue Rider (Der Blaue Reiter), *found posthumously among the Papers of August Macke. Dated October 1911, it is signed by Vassily Kandinsky and Franz Marc.*

"A great spiritual awakening has begun, an equilibrium which was lost is being rediscovered. Spiritual seeds need to to be sown. The first buds are opening. We are on the threshold of the greatest period in human history, an era of great spirituality. From the nineteenth century in which the material blossomed and had its greatest victories, the seeds of a new spiritual age are being sown. The elements of the new spirituality are being formed almost imperceptibly, these elements will nourish the spirit and cause it to blossom. Art, literature, and even "positive" science demonstrate different levels of conversion to the values of the new era, but all succumb. Our major objective is to reflect the artistic events connected with this major turning point and also the facts from other spiritual fields necessary to illuminate them. Although the subjects treated in our pamphlet may appear superficially different, they do in fact have a spiritual connection, it is the similarity in terms of their treatment of the *inner life*. We will pay particular attention not to works which have a definite, recognised, orthodox, exterior form (but which have no higher reason for existing) but to works which have their own inner life and a coherent relationship with this great turning point. It is quite natural, we do not desire that which is dead, we desire the living. Works which have no "inner life" are like the echo of the living voice, just empty shapes. They are not derived from any defined *inner need*. These empty artistic resonances rise forth and smother the roots of this inner need. Like meandering, ghostly, and omnipresent lies these works poison the spiritual atmosphere and lead uncertain spirits astray. They lead the spirit by deception, towards death not towards life. (Unmasking these empty deceptions is our secondary objective.) It is natural that in questions concerning art the first to be asked to speak should be the artist. For his reason the collaborators in our production will be principally artists, presenting them with the possibility to speak freely on issues in which they have previously been silent. We encourage artists who have an inner attraction to our ideals and we invite them to come to us in a brotherly fashion. We use this word sincerely and with the conviction that any formality in its use is beyond suspicion. It is also natural that the people for whom, in the final analysis, the artist works, the public, who rarely have a chance to speak, also have the possibility to express their thoughts and feelings. For this reason we are willing to consider for publication any serious contribution which comes to us. The column "voices" is an open space for short articles and free communication. (In the situation which art finds itself today we we cannot afford not to take into consideration the relationship between the artist and the public, through the medium of critics, which at present is not in a healthy state. Following the development of daily newspapers, the ranks of the serious critics have been infiltrated with contemptible elements who in their empty meanderings have erected a wall not a bridge between between art and the public. So that not only the artist but also the public are able to recognise the distorted views of today's critics, we are going to dedicate a column to this sad and damaging matter.) Since work is not produced to fixed timetables, and life's events do not happen at man's request, our pamphlet will not have fixed publication dates. Publication will be related to he quantity and importance of the material available. It should be superfluous to stress that the principle of internationalism is the only one which is possible for us. A similar principle should be examined however: a single population is one of the creators of the whole and for that reason it should never be identified with the totality. That which is national, in the same way as that which is personal, is automaticallyreflected in every great work. At extreme levels this nuance is irrelevent. This global operation which is called art does not have confines or nationality: it knows only humanity.

[Vasily Kandinsky, Franc Marc, *The Blue Rider,* Munich, 1911]

The Principles of Abstract Art

In 1911 Kandinsky publishes his first great theoretical writing On the Spiritual in Art, *which is unprecedented for its originality in the field of abstract art. The text is still an essential reference work for the understanding of modern art. Below is a quote from a chapter in the first part of the book entitled* Movement.

"The life of the spirit may be represented in a diagram as a large acute-angled triangle divided into unequal segments with the narrowest segment pointing upwards. The lower the segment the greater it is in width, depth and area.
The whole triangle moves slowly, almost imperceptively forwards and upwards. Where today there was the apex, tomorrow there will be the second segment; what today can only be undestood by the apex and to the rest of the triangle is incomprehensible nonsense, tomorrow will be the thoughts and feelings of the second segment, a part of its everyday life. At the apex there is often a man alone. He has a serene gaze but an immeasurable inner sadness. Even those who are closest to him do not understand him. They feel indignant, they label him a trickster and a madman. (....) Artists can be found in all sections of the triangle. Each one who can see beyond the limits of his environment is a prophet to those around him, and helps to move the obstinate whole.

[Vasily Kandinsky, *Concerning the Spiritual in Art,* Munich, 1911]

46

HIS LIFE IN BRIEF

1866. Vassily Kandinsky is born in Moscow on the 4th of December, which corresponds to the 22nd November on the antique Russian Julian calendar which was used until 1916 when the Gregorian calendar was introduced. There is a difference of twelve days between the two calendars.

1871. Kandinsky moves to Odessa with his family. His parents seperate and the young Vasily remains with his father. His mother's sister concerns herself with the boy's education.

1876. In Odessa Kandinsky attends classical high school and has his first tuition in drawing, piano, and cello.

1885. He returns to Moscow to initiate his studies in law and economics.

1889. He stays two months in Vologda and in the Northern province of Moscow in order to carry out research on the law courts. He is enchanted by the popular arts. He visits Ermitage.

1892-93. He marries his second cousin, Anna Fedorovna Semjakina, with whom he lives until 1904.

1896. He remains impressed with the paintings of Monet in an exhibition of his paintings in Moscow. In the same year he takes part in a production of Wagner's *Lohengrin*, this is an important experience for his choice of an artistic direction. He turns down a teaching position at the University of Dorpat and he moves to Munich. He follows the painting course of Azbé, where he meets Aleksej Jawlensky, a fellow-country man and future colleague within the avant-garde.

1900. He takes lessons in the studio of Franz von Stuck. He takes part in the "Exhibition of Moscow Artists".

1901. He founds the artistic association *Phalanx,* this is also a school, and Kandinsky directs the courses in nude and still life painting. He meets Gabriele Münter who becomes his companion.

1903. Exhibitions in Budapest, Prague, Venice, Moscow, Saint Petersburg, and Odessa. Peter Behrens offers him a teaching post in the School of Applied Art of Düsseldorf, Kandinsky turns it down.

1905. Travels to Tunisia with Gabriele Munter. Exhibits in Dresden with friends from the expressionistic movement *Die Brücke,* and subsequently in Berlin, Vienna and Moscow.

1908. Passes the summer in Murnau. He rents lodgings in the artist's quarter of Munich.

1910. He paints *Composition I* in the year when the *First Abstract Watercolour* was created.

1911. Kandinsky meets Arnold Schönberg. He paints his first abstract painting in oil. At the end of the year Kandinsky and Franz Marc found the *Blue Rider*. He becomes friends with Paul Klee.

1914. Exhibitions in Cologne, Munich, Tokyo, Geneva and Hanover. *On the Spiritual in Art* is translated into English. At the outbreak of the war Kandinsky and Gabriele Münter take refuge in Switzerland, he subsequently returns to Russia and takes up Russian citizenship once again.

1916. He seperates from his companion. Exhibitions of his work are held in Berlin, Helsinki, Zurich and L'Aja.

1917. He marries Nina Andreevskaja in February. His first son Vsevolod is born in September of this year, the boy dies in 1920.

1921. He collaborates with Russian Institute of Artistic Culture, assuming responsibility for the physical psychology section. He exhibits his work in New York, Berlin and Cologne. Walter Gropius offers him a teaching post at the Bauhaus School in Weimer.

1925. He moves to Dessau along with the Bauhaus.

1926. He publishes his second book of theoretical writings, *Point and Line to Plane*. His father dies.

1930. He spends his vacation in Italy. He visits Ravenna for the first time and remains fascinated with the mosaics.

1931. He travels in Egypt, Palestine, Turkey, Greece and Italy. Exhibitions of his work are held in Frankfurt, San Francisco, Santa Barbara, Mexico City, Belgrade, Zurich and Brussels. He turns down a teaching position at the Art Student's League of New York.

1933. The Bauhaus is closed down by the Nazi regime. Kandinsky moves to Neuilly-sur-Seine near Paris.

1934. Kandinsky meets Juan Miro, Piet Mondrian, Man Ray, Robert and Sonia Delaunay, Fernand Léger, and Costantin Brancusi.

1936. He spends his vacation in Italy, visiting Genoa, Florence, Pisa and Forte dei Marmi.

1937. Kandinsky's works are banned from German museums. His paintings are exhibited in exhibitions entitled "Degenerative Art" in Munich, Berlin, Lipsia, Hamburg, Salsburg and Vienna until the end of 1941. Kandinsky visits the exhibitions of Arp and Miro.

1939. Kandinsky exhibits in London, New York, Seattle and San Francisco. He organises an important personal exhibition of his work in Paris. Together with Leonide Massine he plans a *Multimedia Ballet*. He becomes a French citizen.

1940. Kandinsky takes refuge in the Pyrenees during the German occupation of Paris. Friends arrange for him to leave from Marseilles to take refuge in New York, but he turns down the offer and decides to stay in Europe.

1944. In his final years Kandinsky participates in numerous exhibitions: at Bucher in Paris with Domela and de Stael, in New York and in Basle. His final personal exhibition is at the Galerie d'Esquisse in Paris. He dies on the 13th of December at the age of seventy eight, of a stroke caused by arterior-sclerosis.

WHERE TO SEE KANDINSKY

The following is a listing of the technical data for the principal works of Kandinsky that are conserved in public collections. The list of works follows the alphabetical order of the cities in which they are found. The data contain the following elements: title, dating, technique and support, size expressed in centimeters.

MUNICH - STÄDTISCHE GALERIE IM LENBACHHAUS (GERMANY)
Red spot II, 1921; oil on canvas, 137x181.

Lyrical, 1911, xylograph, 14.5x21.7.

Improvisation XXVI (Remi), 1912; oil on canvas, 97x107.5

Improvisation (Deluge), 1913 oil on canvas, 95x150.

Nude, 1910; watercolour on light grey cardboard, 33.1x33.

Improvisation XIX, 1911, oil on canvas, 120x141.5.

Impression III (Concert), 1911, oil on canvas, 77.5x100.

NEW YORK (UNITED STATES)
Small pleasures, 1913; oil on canvas, 190.8x119.7; Guggenheim Museum.

Composition VIII, 1923; oil on canvas, 140x201; Guggenheim Museum.

Dominant curve, 1936, oil on canvas, 129.4x194.2; Guggenheim Museum.

Horizontal blue, 1939; watercolor, gouache and blue ink, 24.2x31.7; Guggenheim Museum.

Several circles, 1926; oil on canvas, 140x140; Guggenheim Museum.

ODESSA (RUSSIA)
Urban landscape, 1901; oil on cardboard, 23.5x32; The museum of Art.

Sunny street, 1902; oil on canvas, 23x32; The Museum of Art.

Munich (Study), 1903; oil on canvas 18x28; The Museum of Art.

PARIS - THE NATIONAL MUSEUM
OF MODERN ART (FRANCE)
First abstract watercolour, 1910; watercolour on paper, 49.6x64.8.

Last watercolour, 1944; watercolour, ink and pencil, 25.5x34.6.

Blue of the sky, 1940; oil on canvas, 100x73.

Multicolour ensemble, 1938; mixture of techniques, 116x89.

Movement I, 1935; mixture of techniques, 116x89.

Thirty, 1937; oil on canvas, 81x100.

Composition IX, 1936; oil on canvas, 114x195.

Green emptiness, 1930; oil on cardboard, 35x49.

SAINT PETERSBURG (RUSSIA)
Red church, 1908; oil on ply-wood, 28x19.2; Russian State Museum.

An autumn river, 1908; oil on cardboard, 20x30.5; Russian State Museum.

A summer river, 1908; oil on ply-wood,19.5x29.2; Russian State Museum.

Autumn, 1908, oil on ply-wood, 20x30; Russian State Museum.

House in Murnau, 1909, oil on cardboard, 33x45, Russian State Museum.

Improvisation XI, 1910, oil on canvas, 97.5x106.5; Russian State Museum.

Black spot I, 1912; oil on canvas, 100x130; Russian State Museum.

Composition (Landscape), 1915; watercolour and ink with retouches of white on paper, 22.5x33.8; Russian State Museum.

Composition (Female figure), 1915; watercolour, ink and pen on card, 33.8x22.9, Russian State Museum.

BIBLIOGRAPHY

For a deeper research of the specific periods in the master's artistic development, it is advisable to consult general catalogues of his works. For a basic knowledge the following books can be consulted:

1912 Kandinsky-Marc, *Der blaue Reiter,* München

Kandinsky, *Über das geistige in der Kunst,* München

1926 Kandinsky, *Punkt, Linie zur Fläche,* München

1957 Johannes Eichner, *Kandinsky and Gabriele Munter, at the origins of modern painting,* München

P. Selz, *The Aesthethic Theories of W. Kandinskij,* AB, XXXIX

1958 A. Grohmann, *Wassilij Kandinsky,* Köln, Paris, New York, Milano

1962 V. Kandinsky, *Glances into the past,* Venice

1963 Various authors, *Vassily Kandinsky 1866-1944, a Retrospective Exhibition,* New York, exhibition catalogue

1968 M. Volpi Orlandini, *Kandinskij dall'Art Nouveau alla psicologia della forma,* Roma

1970 A. Bovi, *Vassily Kandinsky,* Firenze

S. Ringbom, *The Sounding Cosmos: a Study in the Spiritualism of Kandinsky and the Genesis of Abstract Painting,* Abo (Finland)

1973-74 V. Kandinsky, *Tutti gli scritti,* edited by P. Sers, Milano

1974 E. Hanfstaengl, *Vasily Kandinsky Zeichnungen und Aquarelle,* exhibition catalogue, München

Various authors, *Homage to Kandinsky,* Paris

1977 P. Vergo, *The Blaue Reiter,* Oxford

Various authors, *Vasily Kandinsky 1866-1944,* München

1982 Hans Roethe, Jean Benjamin, *Kandinsky, annotated catalogue of paintings from 1900 to 1915,* London

Various authors, *Kandinskij und München,* exhibition catalogue, München

1983 Various authors, *Kandinsky's Russian and Bauhaus Years,* exhibition catalogue, New York.

V. Kandinsky and F. Marc, *Letters,* edited by K. Lankheit, Munich

1985 P. Weiss, *Kandinsky in Munich,* Princeton

Various authors, *Kandinsky,* catalogue of the collection of the Museum of Modern Art of Paris, Paris

1986 Various authors, *The Blue Rider,* exhibition catalogue, Bern

1987 R. Tio Bellido, *Kandinsky,* Paris

1988 F. le Targat, *Kandinsky,* London

Rosel Gollek, *The Blue Rider in Lenbachhaus,* Munich

1989 N. Misler, *Avantguardie* russe in "Art and Dossier", n. 49, Firenze

Various authors, *Vasily Kandinsky, first soviet retrospective. Paintings, drawings, and watercolours from soviet museums,* Frankfurt

1990 Various authors, *Astrattismo,* in "Art and Dossier" n.52, Firenze

1991 Duchting Hajo, *Vasily Kandinsky, 1866-1944, the revolution in painting,* Cologne

1992 Various authors, *Kandinsky, watercolours and drawings,* exhibition catalogue, München

P. G. Tordella, *Kandinsky,* Milan

Various authors, *Figures de moderne, 1905-1914. L'expressionisme in Allemagne,* exhibition catalogue, Paris

Chagall

The Falling Angel

Dali

The Persistence
of Memory

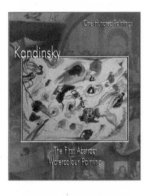

Kandinsky

The First Abstract
Watercolour Painting

Leonardo

The Last Supper

Manet

Le déjeuner sur l'herbe

Raphael

School of Athens

Rembrandt

Supper at Emmaus

Renoir

Moulin de la Galette

Rubens

Garden of Love

Van Gogh

Starry Night

ONE HUNDRED PAINTINGS:

every one a masterpiece

The Work of Art. Which one would it be?
...It is of the works that everyone of you has in mind that I will speak of in "One Hundred Paintings". Together we will analyse the works with regard to the history, the technique, and the hidden aspects in order to discover all that is required to create a particular painting and to produce an artist in general.

It is a way of coming to understand the sensibility and personality of the creator and the tastes, inclinations and symbolisms of the age. The task of "One Hundred Paintings" will therefore be to uncover, together with you, these meanings, to resurrect them from oblivion or to decipher them if they are not immediately perceivable. A painting by Raffaello and one by Picasso have different codes of reading determined not only by the personality of each of the two artists but also the belonging to a different society that have left their unmistakable mark on the work of art. Both paintings impact our senses with force. Our eyes are blinded by the light, by the colour, by the beauty of style, by the glancing look of a character or by the serenity of all of this as a whole. The mind asks itself about the motivations that have led to the works' execution and it tries to grasp all the meanings or messages that the work of art contains.

"One Hundred Paintings" will become your personal collection. From every painting that we analyse you will discover aspects that you had ignored but that instead complete to make the work of art a masterpiece.

Federico Zeri

Coming next in the series:

Matisse, Magritte, Titian, Degas, Vermeer, Schiele, Klimt, Poussin, Botticelli, Fussli, Munch, Bocklin, Pontormo, Modigliani, Toulouse-Lautrec, Bosch, Watteau, Arcimboldi, Cezanne, Redon